Spectrum III

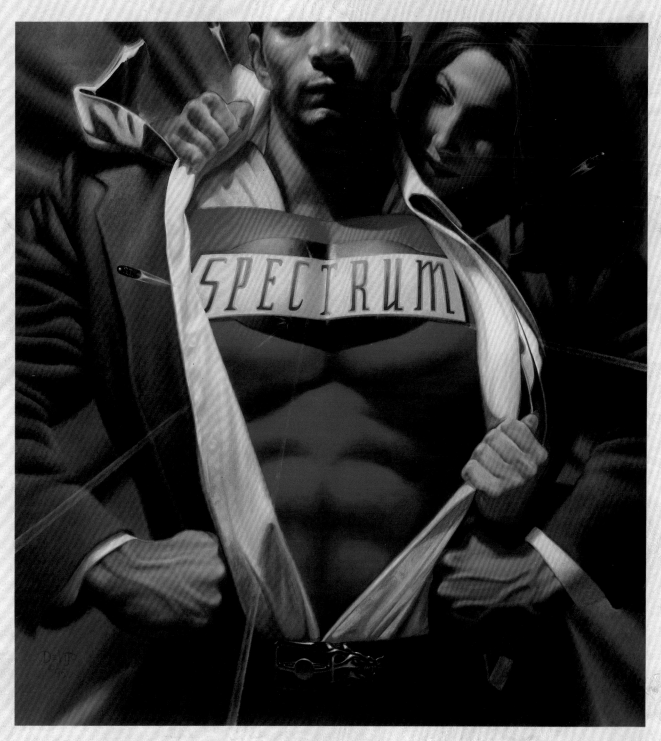

Spectrum 1995
Call for Entries Poster
Painting & concept: **JOSEPH DeVITO**
art director/designer: Arnie Fenner
medium: oil on board
size: 16"x20"

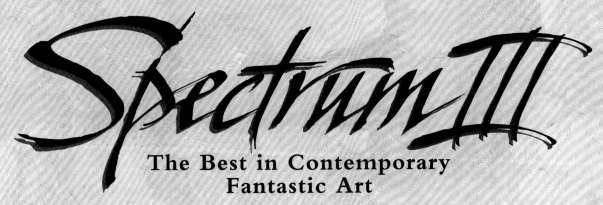

The Best in Contemporary Fantastic Art

Third Annual Collection

Edited By

Cathy Burnett & Arnie Fenner

with Jim Loehr

UNDER WOOD BOOKS

Grass Valley, CA
1996

For information on limited edition fine art prints by James Gurney and Scott Gustafson call The Greenwich Workshop at 1-800-243-4246.

For information on posters and prints by Frank Frazetta write to Frazetta Prints, POB 919, Marshall Creek, PA 98335.

Trade Softcover Edition ISBN 1-887424-09-1
Hardcover Edition ISBN 1-887424-10-5
10 9 8 7 6 5 4 3 2 1

Special thanks to Rick Berry for his continued support and enthusiasm.

Dedicated to the memory of
GEORGE W. FENNER
1922—1995

Recipient of 3 Bronze Stars for valor
during the Battle of the Bulge.
Computer banking pioneer.
Scoutmaster.
Community leader.
Loving husband of 51 years.
Doting grandfather.
A man anyone would be proud to call "Dad."

I was fortunate that he was mine.
A.F.

Published by **UNDERWOOD BOOKS**, P.O. BOX 1607, GRASS VALLEY, CA 95945
TIM UNDERWOOD / PUBLISHER

Contents

Chairman's Message
vi

The Jury
vii

Grand Master Award
viii

The Year in Review
x

The Chesley Awards
xvi

The Show
1

Artist Index
142

Cathy Burnett & Arnie Fenner

Jim Loehr

CHAIRMAN'S MESSAGE

Cathy Burnett, Arnie Fenner
& Jim Loehr

We like to think of each volume of *Spectrum* as a multi-faceted time-capsule that future readers can delve into as a reference guide to the ongoing evolution of fantastic art and the people who create it.

The additions and changes to this third collection are meant to build upon that perception.

The volume of dimensional entries to this year's competition and the unique sensibility of creating 3-D work warranted the separate category you'll discover in the pages ahead. Whereas the "Year in Review" is more of an experiment: it's not an easy task to track trends and highlights of a field as broad and varied as fantastic art and its inclusion in future volumes will depend on how close it comes to achieving its goals. We are also planning on instituting a "Hall of Fame" next year.

Some readers and critics have raised the question as to how work is selected for the *Spectrum* annuals. Or, more directly, "How can this be a 'best of the year' compendium if *fill-in-your-favorite-artist's-name-here* isn't included?"

The field of fantastic art is so incredibly large and diverse that it is virtually impossible for any editor or group of editors to see even close to a majority of the work produced each year—despite intent and diligence something of value would inevitably be overlooked. And even if that approach were taken, the logistics of tracking down usually uncredited artists' addresses and finding out if they wanted to be a part of this book would be a time-consuming nightmare.

The *Spectrum* call-for-entries competition wasn't established to pit talents against each other; rather, it was the only way that we could insure that a jury of creatives had the broadest selection from which to choose and that the artists participate because they *want* to be a part of the process. The rotation of judges each year helps to promote diversity and our attempts to reach an ever-increasing range of creatives, both in the U.S. and abroad, is evidence of our desire to see this project grow. For some there will be disappointments: not everyone who submits work will have it accepted, regardless of status, popularity, or financial success. Likewise, there will always be some artists who choose not to participate and might seem conspicuous by their absence. Hopefully time will change their minds.

But as we've stated from the beginning, reputations and politics don't enter into the equation for *Spectrum*: quality will always be the criterion for inclusion in these annuals.

If that doesn't constitute a subtitle of "year's best", then nothing will.

Our thanks to the creative community for their continued support, to the jury for the arduous task of selecting work for this annual, and to the book-buyers who have enthusiastically embraced this series. With your help we'll be around for quite some time.

Only through art can we emerge from ourselves
and know what another person sees.

MARCEL PROUST

Gary Ruddell
artist

Harlan Ellison
writer/designer

Photograph: Christer Akerberg/Sweden

Bill Nelson
artist

Mike Mignola
artist

Terri Czeczko
art director:
Asimov's SF Magazine
& Analog

Jill Bauman
artist/artists' representative

Denis Kitchen
artist/publisher: Kitchen Sink Press

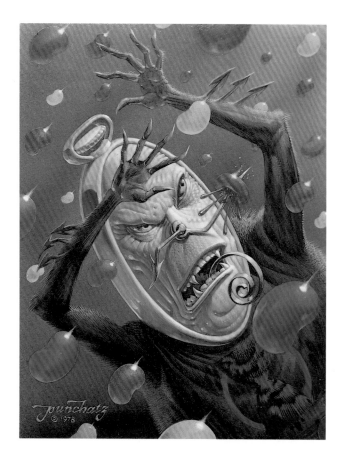

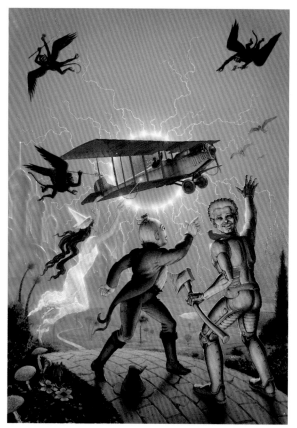

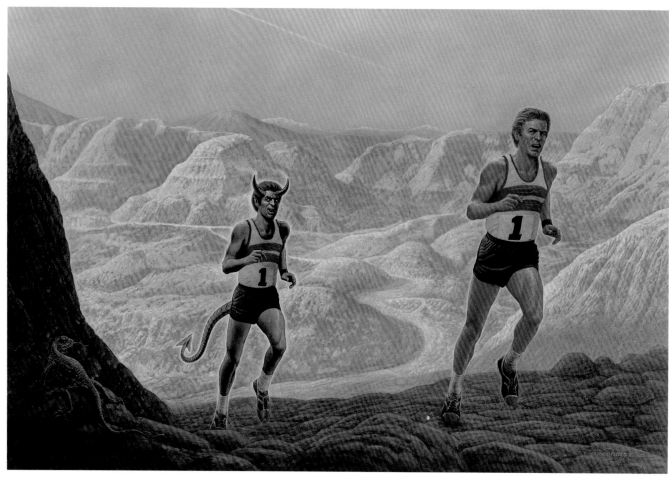

DON IVAN PUNCHATZ

To understand Don Ivan Punchatz, picture him as an artistic chameleon, someone who is able to smoothly change from photo-realist to cartoonist to surrealist to graphic designer as the assignment or his temperament dictates. And while Punchatz has a closet full of stylistic hats he has worn throughout his career, high quality and enormous talent are the two constants that set his art apart from the pack.

Born September 8, 1936, Punchatz grew up in New Jersey ("I was like a real hick," he says) and was entranced by the animated Disney films, the E.C. comics work of Jack Davis, Frank Frazetta, and Wally Wood, and Hal Foster's *Prince Valiant* and Burne Hogarth's *Tarzan* newspaper strips. With his mind set on illustrating comic books he was awarded a scholarship to the School of Visual Arts upon graduating from high school and, surprisingly, fell under the tutelage of his boyhood idol Burne Hogarth.

Hogarth gently dissuaded Punchatz from a career as a cartoonist by introducing him to the broader world of illustration and art history that existed beyond comics. The influence of Salvador Dali, Magritte, and Hieronymous Bosch began to show in his work. Punchatz augmented his education at the School of Visual Arts with 2½ years of night classes at Cooper Union. After graduation he went to work for the New York advertising agency Warwick & Legler, eventually becoming a TV ad-campaign art director.

Drafted in 1959, he worked as a medical-training illustrator at Fort Sam Houston in San Antonio, Texas, while maintaining a freelance career and a career in fine arts. Upon his discharge Punchatz accepted a job as art director for the Pittsburgh agency of Ketchum, MacLeod & Grove. In 1969 he decided to move back to Texas so his children could grow up near his wife's family. Shortly thereafter Punchatz's legendary Sketchpad Studio was born. Employing students he spotted while teaching illustration at Texas Christian University as interns, The Sketchpad became an exciting training ground for some of the nation's top artists, including Stan Watts, Gary Panter, Ray-Mel Cornelius, Roger Stine, Jose Cruz, Georganne Deen, Michael Wimmer, Steve Pietzsch, and Melinda Bordelon.

From *Time Magazine* to Exxon to Pepsi to *National Lampoon* to Berkley Books to *Playboy*, Punchatz's roster of A-list clients is as long and enviable as his list of artistic awards and honors: the quality of his art, regardless of subject matter, sets standards most can only dream of attaining. His work fetches handsome prices in fine art galleries and he is represented in the collections of several major museums, including the Smithsonian Portrait Gallery. Funny, outspoken, and selectively anti-authoritarian, Don Ivan Punchatz is a groundbreaking maverick, not only in the field of fantastic art, but in the worlds of commerical illustration and fine art as well.

The Sketchpad alumni bestowed upon him the title of "The imperial, majestic studio chair of our lord and leader, the ever powerful, dragon and monster renderer and knight of nights, our humble master, giver of paychecks, the illustrious Don Ivan Punchatz."

He's all of that. And more.

born September 8, 1936

THE YEAR IN REVIEW
by Arnie Fenner

Fantastic art, in all its varied forms, is not limited to a handful of magazines or publishers; it's part of the mass consciousness with an appreciation that is cultivated from infancy. There is a fascination with places and people and things that have never been and there are artists and advertisers and publishers and producers happy to provide images to cater to the interests of a world-wide market.

And it's impossible to keep track of everything of value and interest, especially on an international scale. With that in mind, this review is one person's perceptions of the previous year's highlights (primarily *American* highlights at that) and is not exhaustive or all-inclusive by any stretch of the imagination. Anyone involved in any capacity with the fantastic arts is encouraged to provide news, insights, sample products, and observations to us at the Spectrum Design address (listed in the back of this book) for possible inclusion in next year's review.

ADVERTISING

Perhaps no where else in the world of graphics has the computer had as profound an effect as it has had on the field of advertising. Adobe's Photoshop program in particular has changed the way art is being created: the ability to collage, layer, manipulate, paint, and retouch at the click of a mouse (provided you're computer savvy) has inexpensively opened a world of possibilities. It's sobering to look over the previous year's crop of movie posters and realize that the lion's share were created using Photoshop or a similar paint program.

Too, since advertising is historically a short deadline, faceless—with some exceptions—industry (the product is what's supposed to draw your attention, not who called your attention to it), it's natural that computers have gained such ready acceptance and use in the industry.

Which isn't to say that traditionally created art has lost its appeal to advertisers, including software giant Microsoft, whose Canadian ads featured a surreal carnival scene painted by Brad Holland. 1995 saw a wealth

Cover artwork by Chris Moore

of wonderful work for a who's-who of clients by Mark English, John Rush, Jerry Lofaro, Gary Kelley, Carter Goodrich, Daniel Craig, Bill Nelson and literally an army of others. Many believe the most memorable thing about the film *Cutthroat Island* was Drew Struzan's poster. Of special note were Bill Mayer's series of wacky monster paintings for a variety of companies and Mark Fredrickson's schizophrenic, forced-perspective fantasies for everyone from clutch manufacturers to paper companies.

EDITORIAL

The transformation of *Omni* from a newstand magazine into an on-line entity was a sad end for a highly-visible symbol of success for the science fiction field. Though more of a "science" magazine (despite a perplexing focus on fringe-science topics like UFOs in the last year of publication) than one of fiction, the genre had embraced it as one of its own. The decision to go digital seemed overly optimistic at best—it's doubtful that there are 600,000 readers on the Internet who will have the patience or desire to visit on-line. Reading, like viewing art, is a personal activity; the computer, with all its wonders and despite all the "information superhighway" hype, is still incredibly artificial and impersonal.

The magazine, as in years past, featured sophisticated, interpretive illustrations by Michael Parkes, Chris Gall, Gregory Manchess, and Gary Kelley among many others, which made *Omni* a showcase for the cutting edge in fantastic art that will be sorely missed.

Science Fiction Age and *Realms of Fantasy* from Sovereign Media both featured a batch of eye-catching covers and interior work by the likes of John Berkey, Brom, Bob Eggleton, Michael Whelan, Luis Royo, and Steven Assel. Each issue has featured an artist profile and have spotlighted the work of such notables as James Gurney, Brian Froud, Vincent DiFate, and J.K. Potter.

The digest-sized genre magazines, *Asimov's Science Fiction*, *Analog*, and *The Magazine of Fantasy & Science Fiction* continued to hold onto their share of the marketplace, perhaps with the help of non-traditional cover art by Chris Moore, Bruce Jensen, Jill Bauman, Kinuko Y. Craft, and Jim Burns. *Asimov's* and *Analog* (both art directed by Terri Czeczko) featured black and white interior illustrations; the work of Alan Clark and Gary Freeman were periodic standouts.

Cover by Bob Eggleton

Small press magazines like *Interzone*, *Cemetery Dance*, *Pirate Writings*, *Tomorrow Speculative Fiction*, and *Marion Zimmer Bradley's Fantasy Magazine* were markets for professional artists and offered exposure and experience for newer and less well-established traditionalist illustrators. Similarly a host of amateur publications such as *Weirdbook*, *Space & Time*, *Aberrations* and *Eldritch Tales* featured cover and interior art with wildly mixed results. While compensation to artists for these markets is small to nonexistent, they provided a sort of proving ground to novice creatives.

An excellent resource for tracking the news and issues of the science fiction and fantasy field is the monthly *Locus Magazine* (P.O. Box 13305, Oakland, CA 94661. Sample issue: $5.00) which has been a pillar of balanced, well-researched reporting for nearly 30 years. Another source for news and markets is *Science Fiction Chronicle* (P.O. Box 7777, Brooklyn, NY 02892. Sample issue: $4.00).

Naturally, fantastic art turns up regularly in non-genre magazines and newspapers. *Playboy* is still the top editorial showcase for today's best illustrators and, as art directed by Tom Staebler, routinely features stunning work by Wilson McLean, Gary Kelley, Mel Odom, Tim O'Brien, and Kinuko Y. Craft to name only a very few. Anita Kunz, John Collier, and C.F. Payne have produced serious and bitingly satirical art for *Rolling Stone*...and honestly, anyone thumbing through any issues of *Time*, *Boys' Life*, *Texas Monthly*, *New Woman*, *Cricket* or *The New Yorker* was likely to discover worthwhile art by everyone from Don Punchatz to Greg Spalenka to Mark Ryden. And then some.

BOOKS

If you disregard calligraphy and flat graphics (arts unto themselves), there are basically two approaches to fiction book cover art: literal (trying to portray a scene from the story) and interpretive (trying to capture its mood). Which is preferable is debatable, but 1995 produced enough excellent work to please both camps.

Through a combination of aggressive advertising and innovative marketing, White Wolf Publishing quickly established its position in the industry. Applying edgy, "big book" design to their projects they guaranteed that their line at least stood out from the other genre publishers. Covers by Kent Williams (*Elric: Song of the Black Sword*), Janet Aulisio (*Von Bek*), and Mike Mignola (*Ill Met in Lankhmar*) were especially noteworthy.

Michael Whelan announced that at the end of 1995 he would start a 2-year sabbatical from commercial illustration to pursue his fine arts career. His exceptional covers for *Beowulf's Children* (Tor), *Crown of Shadows* (DAW), and *Feersum Endjinn* (Bantam) will have to satisfy readers until his return. John Jude Palencar provided beautiful work for *Evolution's Shore* (Bantam) and *The Dream Cycle of H.P. Lovecraft* (Ballantine) while Mel Odom produced wonderful covers for the erotic *Little Deaths* (Dell)

Artist Michael Whelan

and *Dark Love* (Roc). Other jacket art of note included work by Dorian Vallejo (*The Shape-Changer's Wife*/Ace), Nicholas Jainschigg (*Women at War*/Tor), Josh Kirby (*Maskerade*/Gollancz), Gary Ruddell (*Remake*/Bantam), Courtney Skinner and Newells Convers (*The Wizardry Consulted*/Baen), Vincent DiFate (*Harvest the Fire*/Tor), Jim Burns (*Seasons of Plenty*/HarperCollins), Richard Bober (*Caldé of the Long Sun*/Tor), Dennis Nolan (*Alvin Journeyman*/Tor), Bruce Jensen (*Mainline*/Tor), Stan Watts (*Worldwar: Upsetting the Balance*/Del Rey), Jody Lee (*Hunter's Oath*/DAW), Tom Canty (*The Year's Best Fantasy & Horror Vol. 8*/St. Martin's), Rick Berry (*The Furies*/Tor), and Janny Wurts (*Keeper of the Keys*/HarperCollins.) And that barely scratches the surface! Robert McGinnis, Manuel Sanjulian, Donato Giancola, Don Maitz, Bob Eggleton, Yasutaka Taga, Wilson McLean, Michael Koelsch, Stephen Youll, Les Edwards, and Joe DeVito along with a long list of others created works of art that transcended genre throughout the year.

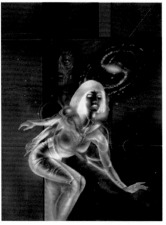

Bruce Jensen's cover for Mainline

There were a healthy number of single artist collections in 1995. Britain's Paper Tiger released *Electric Dreams: The Art of Barclay Shaw*, *Alien Horizons: The Fantastic Art of Bob Eggleton*, *Hard Curves: The Fantasy Art of Julie Bell*, and *Bodies*, a selection of Boris Vallejo's art/referance photography. Charles F. Miller produced *The Hannes Bok Showcase* edited by Stephen D. Korshak and *Stephen E. Fabian's Women & Wonders*. Morpheus International broke with their tradition of showcasing non-American artists like H.R. Giger and Jacek Yerka and published *The Alien Life of Wayne Barlow* while Arts Nova Press released Alan Clark's disturbing *The Pain Doctors of Suture Self General*. French fantasist Moebius (Jean Giraud) was well-represented with a pair of books, *Moebius: Fusion* (Marvel) and *Virtual Meltdown: Images of Moebius* (Graphitti Design). *DinoPix* by Teruhisa Tajina (Chronicle Books) is a fun photo-illustrated fantasy of saurians roaming the streets. Houghton-Mifflin unveiled *J.R.R. Tolkien: Artist and Illustrator* while Bantam released *The Illustrated Star Wars Universe* featuring the art of Ralph McQuarrie. Dark Horse produced *Visions: The Art of Arthur Suydam* and *Richard Corben's Art Book Volume 2* came out from Fantagor Press.

The best children's books appeal to people of all ages and this year's crop is no exception to that rule.

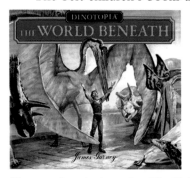

James Gurney returned to the bestseller lists with his delightful *Dinotopia: The World Beneath* (Turner) and there's the promise of a feature film in the works. Leo and Diane Dillon beautifully illustrated *Her Stories: African American Folk Tales* (Blue Sky Press) and Robert Florczak captured the spirit of Maxfield Parrish with his paintings for *The Rainbow Bridge* (Harcourt Brace). Lauren Mills and Dennis Nolan produced a wonderful body of work with *Fairy Wings* (Little, Brown) and Daniel Adel hilariously painted the characters of *The Book that Jack Wrote* (Viking Penguin). David Shannon's paintings for *The Ballad of the Pirate Queens* (Harcourt, Brace) are as gorgeous as Alan Snow's for *The Truth About Cats (Little, Brown)*—they're from outer space you know—are humorous. William Joyce, Lane Smith, Gahan Wilson, and Charles Santore among many more created exceptional and imaginative work for a variety of titles.

Bud Plant is the source of choice for *all types* of illustrated books and artist collections and has been for 25 years. $3.00 (refunded with an order) will get interested parties a profusely illustrated (and indexed) catalog. His address is: Bud Plant Comic Art, P.O. Box 1689, Grass Valley, CA 95945.

COMICS

All businesses have their ups and downs, but the comics industry always seems to be in a period of either feast or famine. 1995 was a famine period. Fueled by a speculators' market and media attention in the early

'90s, a slide that started in mid-1994 turned into a jumbled crash in '95. The way comics were sold to retailers changed radically as Marvel bought their own distributor leaving the other two major distribution companies scrambling to sign other major publishers to exclusive deals in an attempt to fill the gap left by #1 Marvel's departure. Overall sluggish sales of comics forced some store owners to diversify product (not necessarily a bad thing) while others went out of business. By year's end, several smaller publishers ceased to exist and even some of the majors canceled complete lines and laid-off staff members.

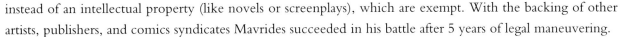

To add to the industry's headaches comics shops around the country were targeted by the police for obscenity with increasing frequency and the non-profit Comic Book Legal Defense Fund was kept busy bailing retailers out of jail and hiring attorneys. Comics published by Fantagraphics' Eros line and heavy-metal rocker Glenn Danzig's company Verotik were those most often cited for cause.

One positive legal note was *Fabulous Furry Freak Brothers* artist Paul Mavrides' victory over California's Board of Taxation which was attempting to make he and other cartoonists pay the state sales tax as though their work were a commodity instead of an intellectual property (like novels or screenplays), which are exempt. With the backing of other artists, publishers, and comics syndicates Mavrides succeeded in his battle after 5 years of legal maneuvering.

Despite the year's gloomier aspects, there was a volume of innovative, entertaining work produced in 1995. D.C., fueled by the success of their latest Batman blockbuster film (*Batman Forever*), continued to mix their line with traditional superhero favorites and the more off-beat adult oriented Vertigo imprint. Dave McKean's Photoshopped *Sandman* covers and *Mr. Punch* graphic novel, John Bolton's art for the limited

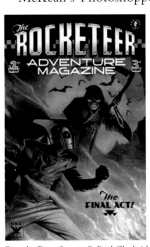

Cover by Dave Stevens & Paul Chadwick

ManBat series, Tony Salmon's interiors and Mark Chiarello's paintings for *Vigilante*, Rick Berry's *Animal Man* covers, and Carl Critchlo's and Dermot Power's *Batman/Judge Dredd: The Ultimate Riddle* were only a handful of the excellent work they published. Marvel and D.C. collaborated at the end of the year with a series of cross-over titles that matched heroes and villains from each company.

Dark Horse Comics (who likewise capitalized on the success of tie-in movies like *The Mask* and *Time Cop*) produced an eclectic mixture of licensed titles with creator-owned properties. Mike Mignola's supernatural demon/detective Hellboy cropped up in several mini-series and the trade paperback collection *Hellboy: Seed of Destruction* while Geof Darrow's 2-issue *Big Guy and Rusty the Boy Robot* (written by Frank Miller) was a wonderfully manic tribute to Japanese monster movies and animation. Dave Dorman's *Star Wars* and *Indiana Jones* covers, Gary Gianni's work on *The Shadow: Hell's Heat Wave*, Steve Rude's art for *Nexus*, Paul Chadwick's *Concrete*, Arthur Suydam's paintings for *Tarzan: The Lost Adventure,* the multi-artist series *Harlan Ellison's Dream Corridors*, and Dave Stevens' long-awaited finale to *The Rocketeer* made Dark Horse worth keeping track of.

Visionary E.C. artist Al Williamson returned to Mongo with his 2-issue *Flash Gordon* mini-series for Marvel. Tristan Schane, Chris Ivy, Barry Windsor-Smith, M.C. Wyman, and Simon Bisley also created dynamic work for the company. Image Comics showcased notable art by Todd McFarlane, Mike Turner, Sam Keith, and Jeff Smith while Charles Vess created his own imprint and self-published his beautiful *Book of Ballads and Sagas*. Techno Comix showcased moody work by Daniel Brereton, Tom Simonton's *Amazon Tales* for Fantaco was eye-popping fun, and the controversial Verotik somehow managed to lure the legendary Frank Frazetta back to comics with covers for *Jaguar God, Verotika,* and *Death Dealer.*

Kitchen Sink published interesting work by Charles Burns, Mark Schultz, and Eddie Campbell while the

success of the documentary *Crumb* helped create wide-spread demand for books, candy bars, and squeaky toys featuring the artist's work. Bill Sienkiewicz's painted biography of Jimi Hendrix, *Voodoo Child*, was an exercise in surrealistic excellence and *Alex Toth* was a fitting tribute to a cranky genius. Their ongoing series of *Li'l Abner* reprints and the two-volume reference book *The Comic Strip Century* were valuable additions to any library of comics history.

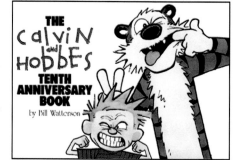

Vincente Segrelles' *The Mercenary: The Voyage* (NBM) and miscellaneous work by Joe Chiodo, Adam Hughes, Peter Kuper, Rick Geary, Joseph Linser, Alex Ross, Mark Edmond, P. Craig Russell, and Michael William Kaluta were all worth looking for. And one couldn't pass by Andrews & McMeel's *The Calvin & Hobbes 10th Anniversary Book*, published just before creator Bill Waterson announced the newspaper strip's retirement.

Although there are a fair number of magazines and newspapers devoted to the comics field, the industry is in desperate need of a neutral trade journal that can report news and address issues in a bipartisan manner without being so reliant on publishers' puff promotions and advertising. Until comics has the equivalent of a *Publishers Weekly* (and the field's participants have an organization to help solve disputes professionally) the industry will probably continue to shoot itself in the foot every few years.

<h2 style="text-align:center">DIMENSIONAL</h2>

The number of gifted sculptors producing knock-out work is truly amazing. Something of an offshoot of the "garage kit" underground (one or two person companies that create original model kits in editions of 20 to 100), there are a number of firms now manufacturing statues and models for the collectors' market.

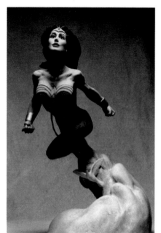

Randy Bowen was responsible for a quantity of fine pieces for a spectrum of clients: *The Shadow* and *The Crypt-Keeper* (designed by William Stout) for Graphitti Design, *The Sandman* for D.C., *Grendel* for Bowen Design, and Frank Frazetta's *The Death Dealer* for Dark Horse is just a partial list of work by this popular and influential artist.

Japan's Volks Modeling produced minutely detailed models based on the SF-flavored pin-up art of Hajime Sorayama while Yasushi Nirasawa designed the sinister anime character *Devilman* for Fewture Models. Stateside, Mark Newman, Tony McVey, Chris Walas, Steve Wang, and the team of Ken Morgan and Dan Platt all sculpted a stunning array of creatures.

Clayburn Moore superbly straddled careers in commercial and fine art, with a bronze minotaur ("Taurus") and a winged maiden ("Celestial Jade") on one side and comics characters *Pitt* (Image) and *Hannah & Sabertooth* (Kitchen Sink) on the

Sculpture by Joe DeVito/© & TM D.C.

other. Joseph DeVito produced a *Wonder Woman* statue for D.C. and Steve West interpreted Boris Vallejo's "Primeval Princess" in 3-D.

Amazing Figure Modeler (P.O. Box 30885, Columbus, OH 43230/$7.00 for a sample issue) is an excellent and colorful introduction to this fascinating and growing field.

<h2 style="text-align:center">INSTITUTIONAL</h2>

Trading cards, calendars, portfolios, packaging, posters, greeting cards—all fall under the category of "institutional" and it's all challenging to keep up with.

The non-sports trading card business, after several years of rapid growth, experienced an economic down-turn that coincided with the slump in the comics industry. Some announced artists' sets were canceled while press-runs were cut drastically on others. The somewhat stiff price for a pack of 8 to 10 cards (anywhere from $1.50 to $5.00) probably didn't help matters. Still, there were some nice collections of art

published that were worth hunting down. FPG released top-quality sets by Jeffrey Jones, Joe DeVito, Paul Chadwick, Jim Steranko, Chris Achilleos, Brom, and J.K. Potter along with Joe Jusko's Burroughs cards; Comic Images produced compilations of art by Michael Whelan, Frank Frazetta, Luis Royo and Boris Vallejo; Topps covered *Mars Attacks*, *The X-Files*, *Star Wars*, and *Vampirella* while Marvel's characters were handled by Fleer and D.C.'s by Skybox. It seemed you couldn't turn around in 1995 without stumbling across a new card set. As sales began to decline, the publishers started to develop card games similar to Wizards of the Coast's phenomenally successful *Magic: The Gathering*. Whether the role-playing game market (traditionally dominated by TSR, Palladium, and FASA) suffers at this infusion of new companies or

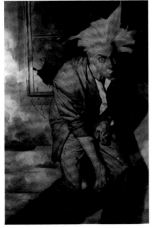

Fine art print by Phil Hale

the trading card business begins to rebound are questions 1996 will answer.

It was another strong year for calendars with wonderful selections by James Gurney, Frank Frazetta, H.R. Giger, Boris Vallejo, David Mattingly, and Roger Dean. Multiple-artist calendars included *Heavy Metal* (Julie Bell, Rowena, etc.), *Lady Death* (Steven Hughes, Joseph Linser, etc.), and Morpheus (Jacek Yerka, De Es, etc.). Perhaps the nicest calendar that unfortunately too few people saw was Wizards of the Coast's *Everway*, featuring original work by Frank Frazetta, Brian Froud, Rick Berry, Glenn Fabry, and Geof Darrow among others.

A number of fine art prints made it to the market in 1995 with the Greenwich Workshop again leading the way with fabulous offerings by James Gurney, James Christensen, Thomas Blackshear, Scott Gustafson, and Bev Doolittle. Mill Pond Press released some great work by Dean Morrissey and Don Maitz while Graphitti

Design continued with their series of James Bama's *Doc Savage* paintings, both as signed limited editions and unsigned posters. The Steltman Gallery out of Amsterdam produced reasonably priced prints by Michael Parkes, Glass Onion Graphics exclusively offered the work of Michael Whelan, and Glimmer Graphics showcased the art of Jon Muth, Phil Hale, Alan Lee, Brian Froud, and Jeffrey Jones.

There were a number of portfolios as well with *Dame Lucifer* by Joseph Linser (SQ Productions), Michael Kaluta's *Mage Portfolio* (White Wolf), *Vertical Curves* by John Zeleznik (published by the artist), *Demon Baby* by Steve Fastner and Rich Larson (SQ Productions), and *Vampir* by John Bolton (Modern Graphics) being some of the most eye-catching. Fantasy pin-ups was a dominant theme.

There are plenty of places to buy original art, including directly from some creators, but one of the most valuable sources is Jane Frank's Worlds of Wonder (P.O. Box 814, Mclean, VA 22101, phone 703-790-9519), which represents a number of the fantastic field's finest artists. Illustrated catalogs are available.

1995 saw an infinite number of mousepads, screen-savers, toys, greeting cards,

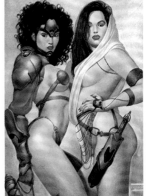

Greeting card by John Zeleznik

T-shirts, games, gee-gaws and doohickies that featured fantastic art throughout the year. There were numerous exhibitions, countless convention art shows, and stacks of interesting self-promotional work. Finding out about them is easy: listing them just isn't feasible in the space available.

A FINAL WORD ABOUT CRIME

Every artist's nightmare came true for Janny Wurts and Don Maitz on October 26 when a crate of 23 of their paintings being shipped for exhibition at the World Fantasy Convention in Baltimore, MD, was stolen from a Federal Express truck. The FBI is involved and a $5000 reward has been offered for their return, damaged or whole. Anyone with information can contact the artists via FAX at 941-925-3494, or Federal Express Security/Bob Brown at 215-937-4700, or the artists' publishers: HarperCollins, Laura Baker/publicist, 212-207-7000/FAX 7759, and FPG, Michael Friedlander, 412-854-0200/FAX 4470.

THE CHESLEY AWARDS

The Chesley Awards are presented annually by the Association of Science Fiction & Fantasy Artists in recognition of works and achievements by individuals in a given year. For more information about the organization write to ASFA, P.O. Box 825, Lecanto, FL 34460.

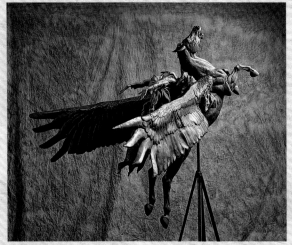

JENNIFER WEYLAND
dimensional [1993]

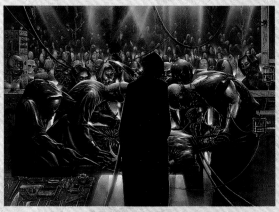

ALAN M. CLARK
unpublished/color

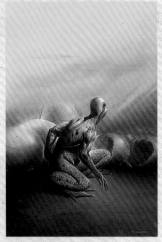

WOJTEK SIUDMAK
magazine cover

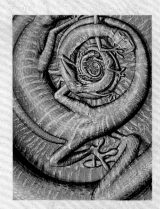

ALAN M. CLARK
paperback cover

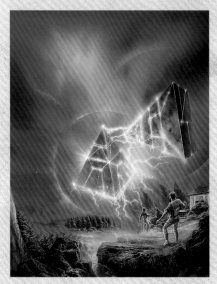

BOB EGGLETON
magazine cover

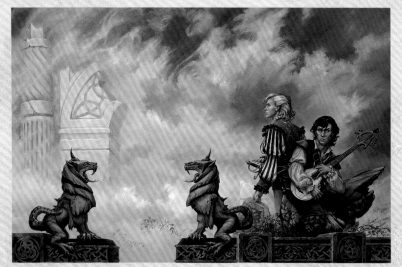

JANNY WURTS
hardback cover

Best Cover Illustration/Hardback:
Janny Wurts for *Curse of the Mistwraith*
Best Cover Illustration/Paperback:
Alan M. Clark for *Geckos*
Best Cover Illustration/Magazine [tie]:
Bob Eggleton (Asimov's SF 8/94)
Wojtek Siudmak (Analog SF 12/94)
Best Interior Illustration:
Brian Froud for *Lady Cottingham's Pressed Fairy Book*
Best Monochrome Work/Unpublished:
Carl Lundgren for "Promise"
Best Color Work/Unpublished:
Alan M. Clark for "The Pain Doctors of
Suture Self General"
Best Three-Dimensional Art:
Clayburn Moore for *Pitt.*
Best Art Director:
Cathy Burnett and Arnie Fenner
Award for Artistic Achievement:
Frank Frazetta

The Show

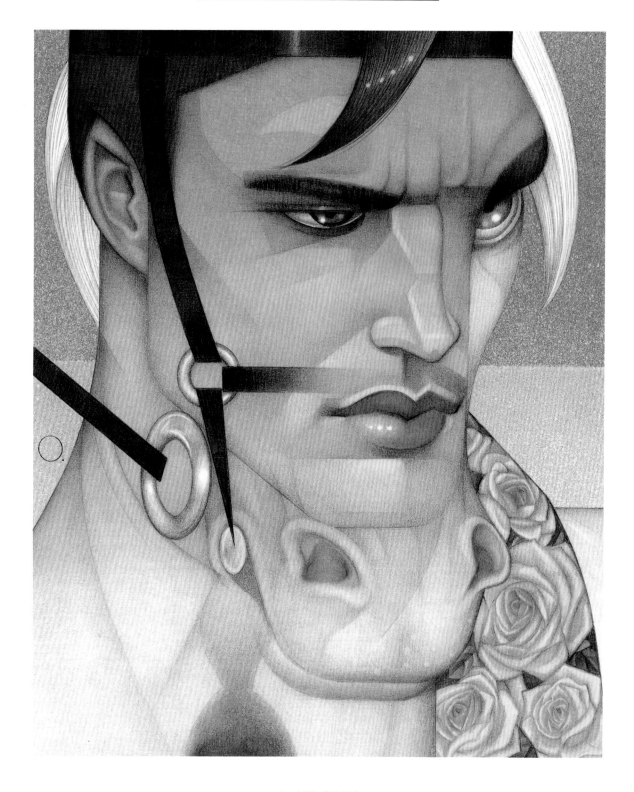

artist: **MEL ODOM**
art director: Tom Staebler
designer: Kerig Pope
client: Playboy
title: The Stallion

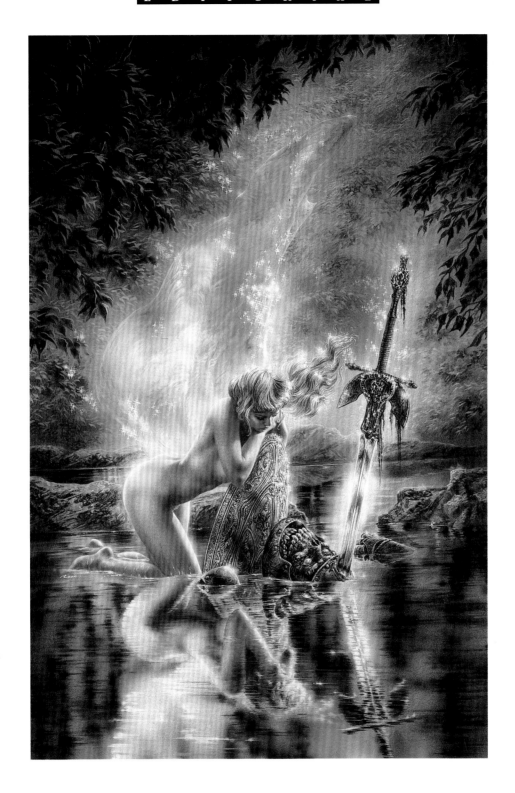

artist: **LUIS ROYO**
art director: Luis Royo
client: Heavy Metal
title: Wings of Reflection
medium: Inks & acrylic
size: 12"x18"

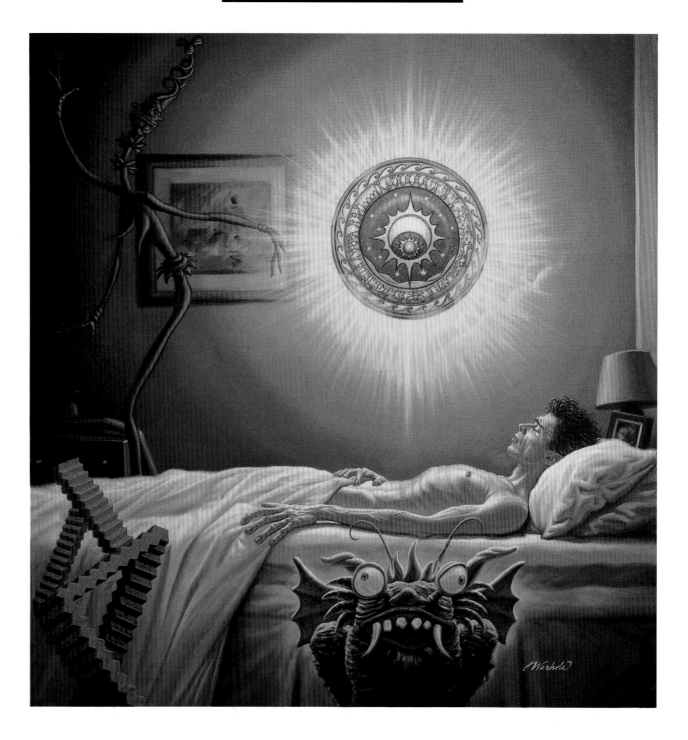

artist: **JAMES WARHOLA**
art director: Tom Staebler
designer: Kerig Pope
client: Playboy
title: The Second Shield
medium: Oil on canvas
size: 20"x20"

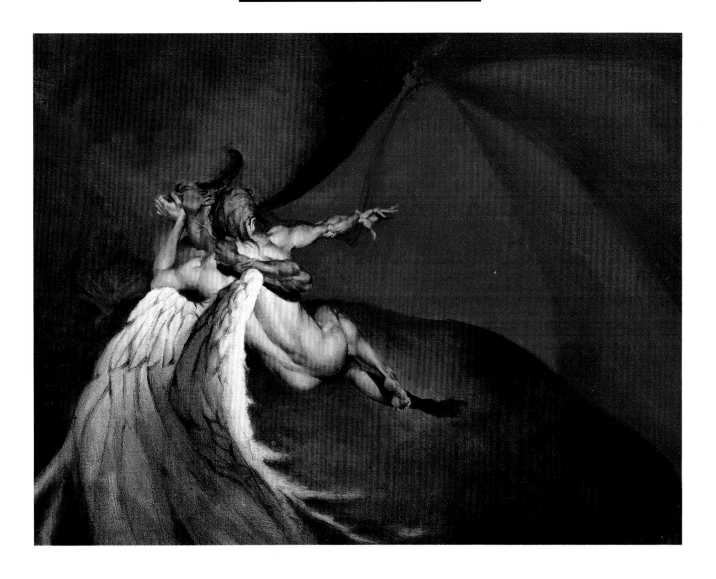

artist: **ROBH RUPPEL**
art director: Robin Ramos
client: Inquest Magazine
title: The Fall
medium: Oil
size: 12"x16"

1
artist: **JAMES WARHOLA**
art director: Tom Staebler
designer: Kerig Pope
client: Playboy
title: The Ghost Standard
medium: Inks on cell
size: 24"x24"

2
artist: **WILL WILSON**
art director: John Sanford
client: The Learning Channel
title: Minotaur
size: 11½"x16½"

3
artist: **JIM BURNS**
art director: Terri Czeczko
designer: Terri Czeczko
client: Analog
title: Final Review
medium: Acrylic
size: 18"x24"

4
artist: **GREGORY MANCHESS**
art director: Christine Dunleavy
client: Philadelphia Inquirer
 Magazine
title: Fall Fiction
medium: Oil
size: 24"x24"

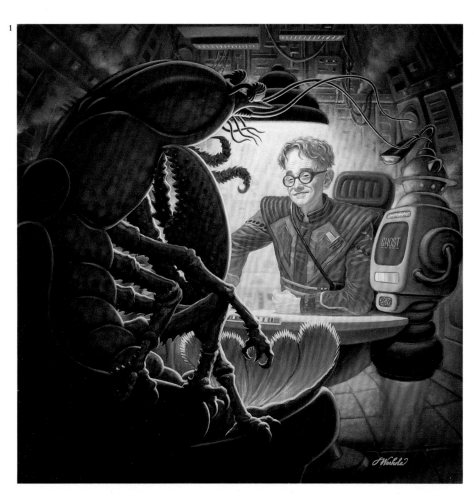

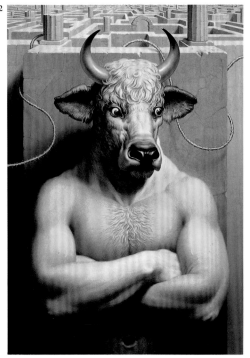

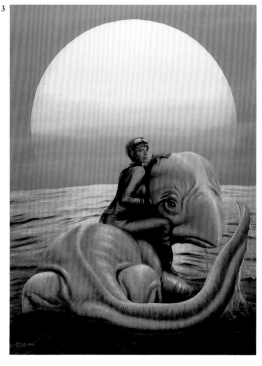

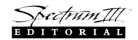

4

1
artist: **ISTVAN BANYAI**
art director: Tom Staebler
designer: Kerig Pope
client: Playboy
title: Heroin Chic
medium: Inks on cell
size: 11"x14"

2
artist: **DAVID PLUNKERT**
art director: Tom Staebler
designer: Kristin Korjenek
client: Playboy
title: Lesbian For A Day
medium: Collage

3
artist: **FRANCOIS ESCALMEL**
art director: Francois Escalmel
designer: Sv Bell
client: Imagine
title: Spring Crucifixtion
medium: Digital
size: 5¼"x8¼"

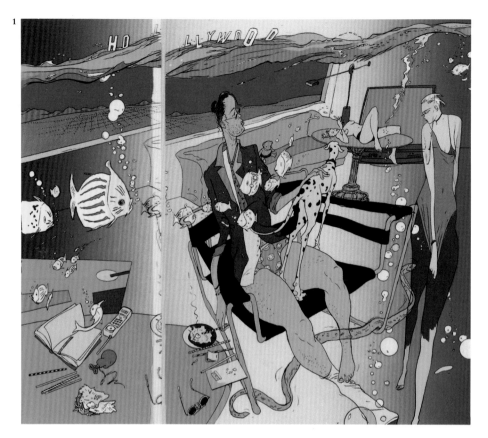

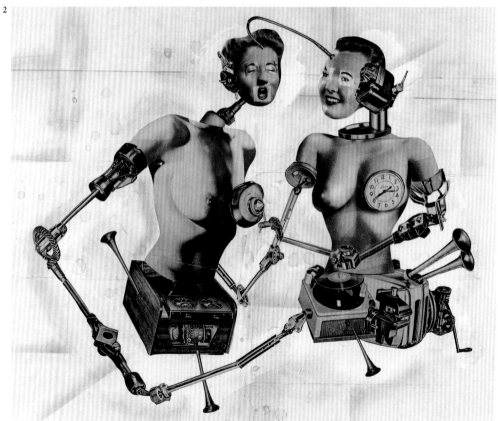

3

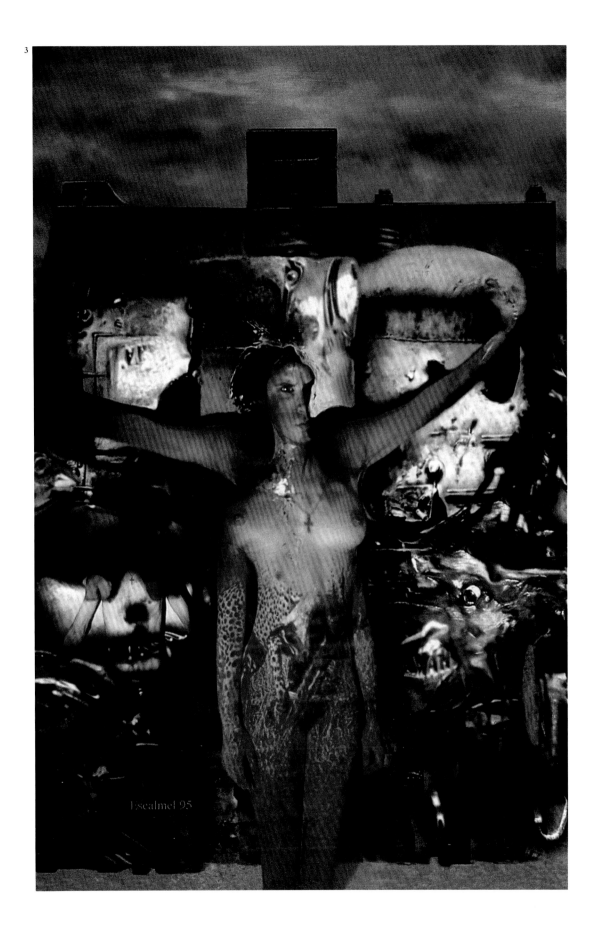

Escalmel 95

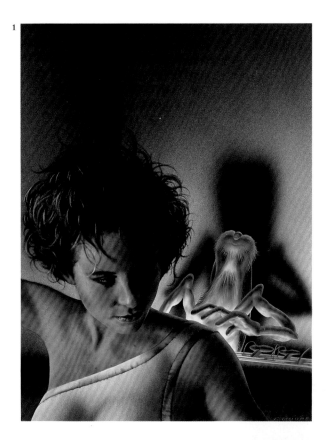

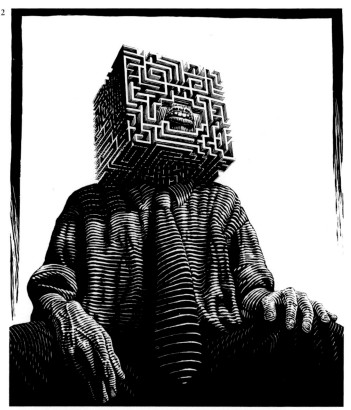

1
artist: **CHRIS MOORE**
art director: Terri Czeczko
client: Analog
title: The Height of Intrigue
medium: Acrylic
size: 11"x22"

2
artist: **PATRICK ARRASMITH**
art director: Steven Heller
client: New York Times
title: Minds Beyond Themselves
size: 8½"x11"
medium: Scratchboard

3
artist: **TODD LOCKWOOD**
art director: Carl Gnam
client: Science Fiction Age
title: After
medium: Acrylic
size: 17½"x17½"

4
artist: **KINUKO Y. CRAFT**
art director: Terri Czeczko
designer: Terri Czeczko
client: Asimov's Science Fiction
title: Seven Wonders
medium: Mixed
size: 15"x18"

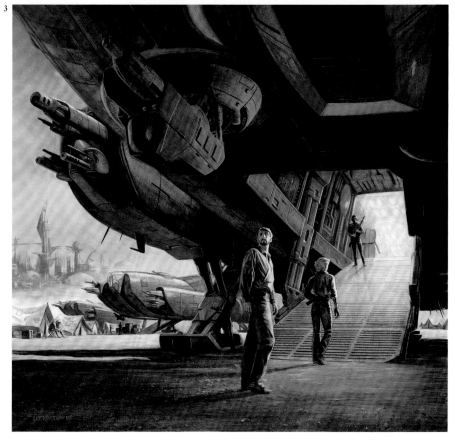

4

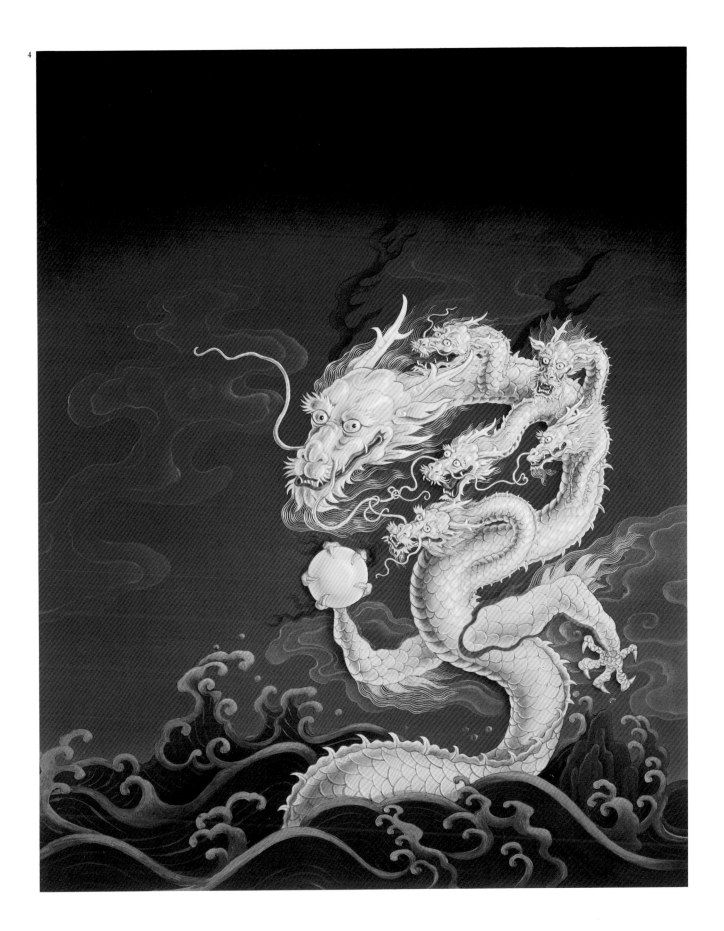

1
artist: **MICHELANGELO MIANI**
art director: Michelangelo Miani
client: Futura Magazine
title: Dawn Wing
medium: Gouache
size: 50cmx70cm

2
artist: **LEAH PALMER**
art director: Ron McCutchan
client: Cricket Magazine
title: The Old Man and the Cat
medium: Mixed
size: 7⅞"x7⅞"

3
artist: **STU SUCHIT**
art director: John Dana Gibson
designer: John Dana Gibson
client: Read Magazine
title: The Beast from 20,000 Fathoms
medium: Mixed
size: 11"x17"

4
artist: **TIM O'BRIEN**
art director: Tom Staebler
designer: Tom Staebler
client: Playboy
title: His Master's Voice
medium: Oil on canvas
size: 12"x18"

1

2

3

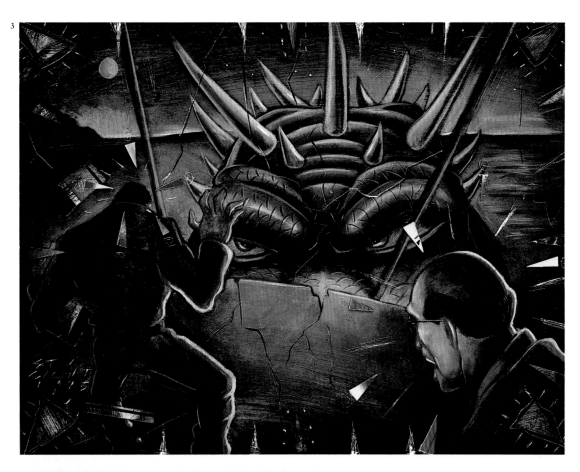

4

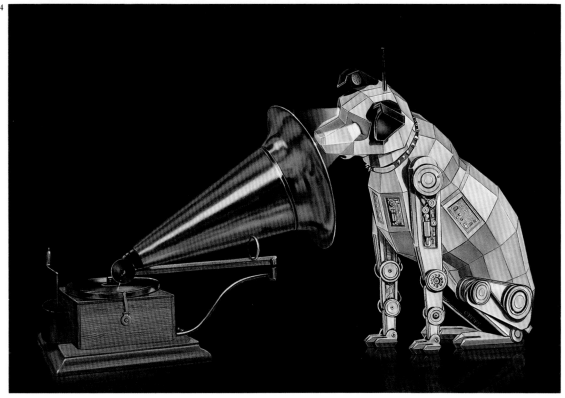

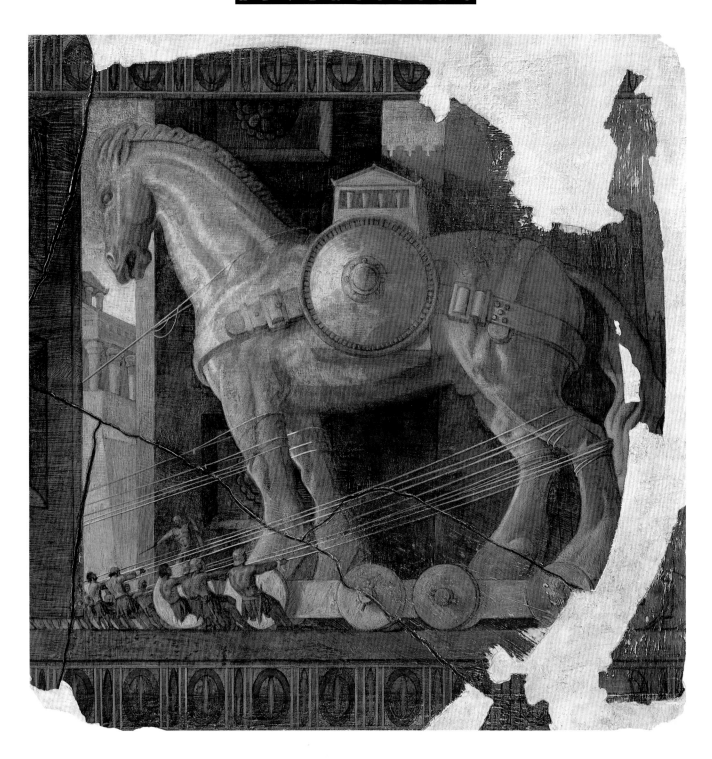

artist: **JOHN RUSH**
art director: Steve Thompson
advertising agency: Traverron Back, Inc.
client: Johnson Controls, Inc.
title: The Trojan Horse
medium: Gouache
size: 20"x20"

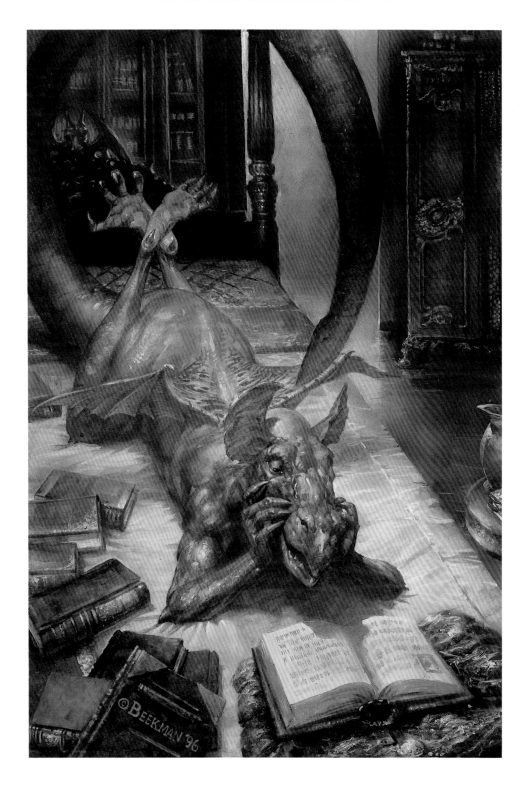

artist: **DOUG BEEKMAN**
art director: Jeff Brenner
client: SFBC/Doubleday
title: Bookwyrm
medium: Acrylic on board
size: 17"x27"

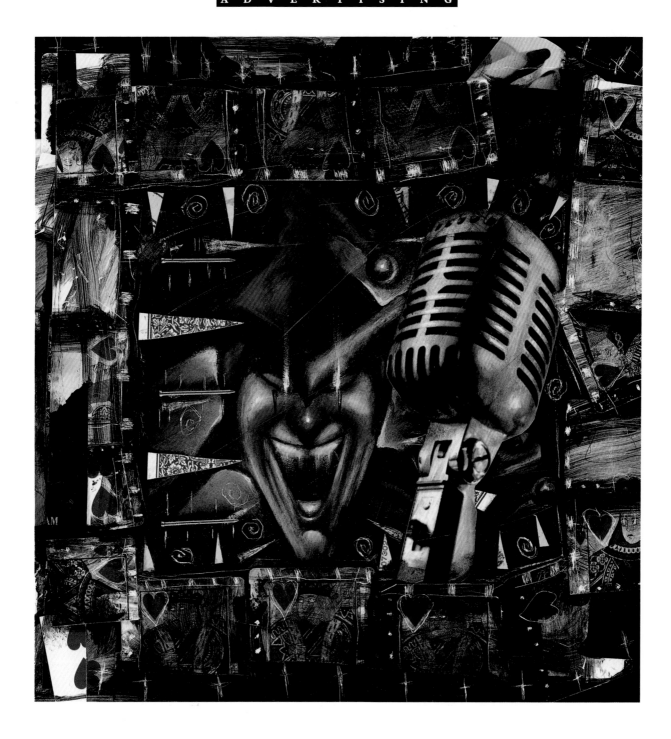

artist: **STU SUCHIT**
art director: Mike Cavallaro
client: Reservoir Records
title: Sticks & Stones/New Heart
medium: Collage
size: 12"x12"

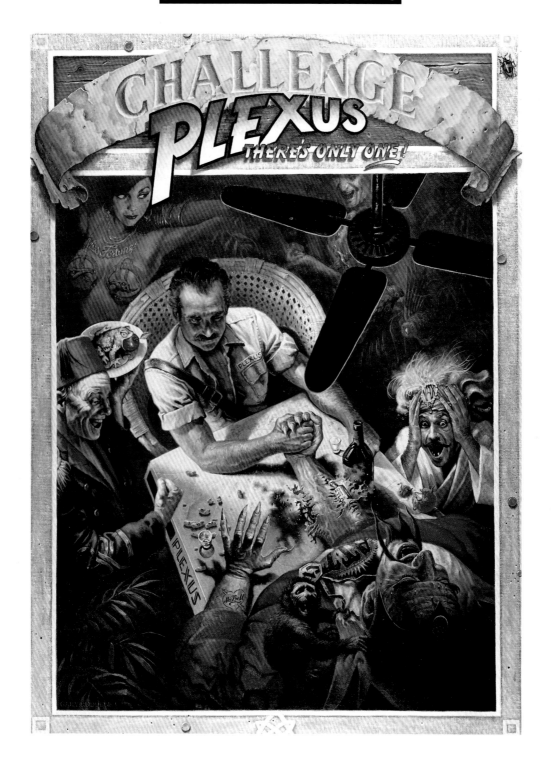

artist: **GARY RUDDELL**
art director: Mark Harris
designer: Gary Ruddell
client: Plexus, Inc.
title: Plexus Challenge
medium: Oil
size: 24"x36"

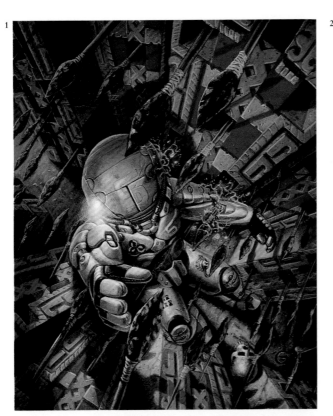

1	2	3	4
artist: **GARY GLOVER**	*artist:* **DAVE KRAMER**	*artist:* **GLENN KIM**	*artist:* **GARY GLOVER**
art director: E.J. Dixon	*art director:* Terri Soo Hoo	*art director:* Alvin Gardona	*art director:* E.J. Dixon
designer: E.J. Dixon & Phil Saunders	*client:* SooWoo Design	*client:* Visual Concepts	*designer:* E.J. Dixon & Victor Navone
client: Presto Studios CD Rom	*title:* The Riddle of Master Lu	*title:* Death Sprawl	*client:* Presto Studios CD Rom
title: Agent 5, In Mayan Spear Trap	*size:* 12½"x14½"	*medium:* Acrylic	*title:* Agent 5, DaVinci's Courtyard
medium: Acrylic	*medium:* Oil	*size:* 20"x8½"	*medium:* Acrylic
size: 9"x12"			*size:* 9"x12"

4

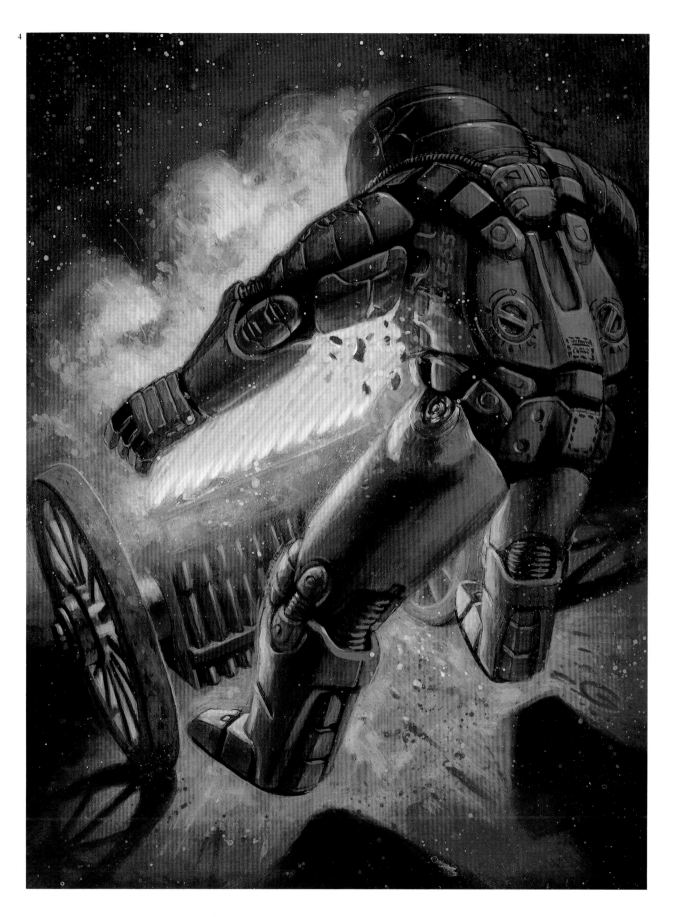

artist: **JOHN JUDE PALENCAR**
art director: Jerry Todd/George Cornell
designer: Jerry Todd/John Jude Palencar
client: Penguin U.S.A./R.S.V.P.
title: Becoming Human
medium: Acrylic
size: 24¾"x27"

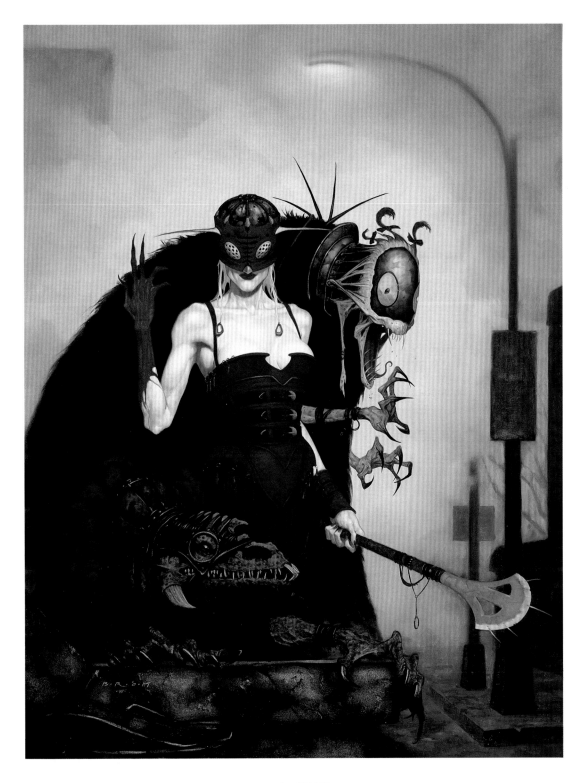

artist: **BROM**
art director: Kevin Siembieda
client: Palladium Books
title: Night Spawn
medium: Oil
size: 15"x19"

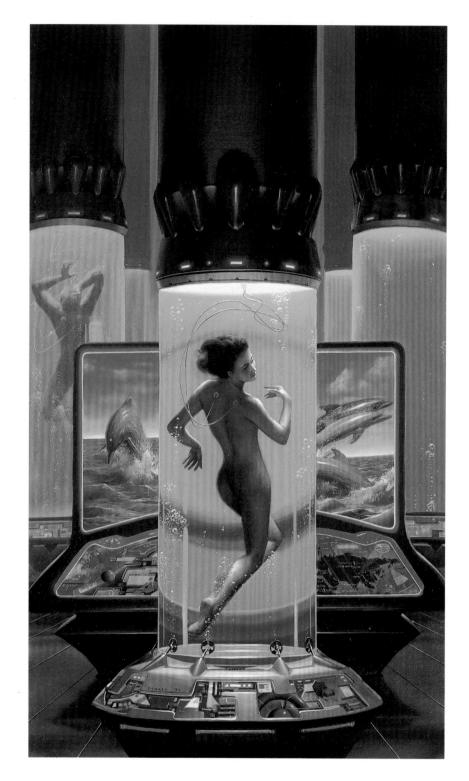

artist: **DONATO GIANCOLA**
art director: Jamie Warren Youll
client: Bantam Books
title: Lethe
medium: Oil on paper
size: 16"x27"

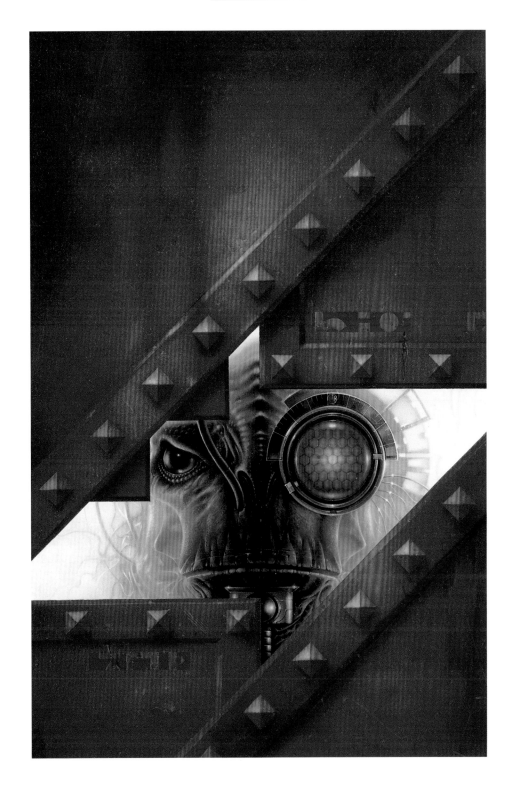

artist: **BRUCE JENSEN**
art director: Judith Murello
client: Berkley Publishing Group
title: The Final Battle
medium: Acrylic
size: 13"x20"

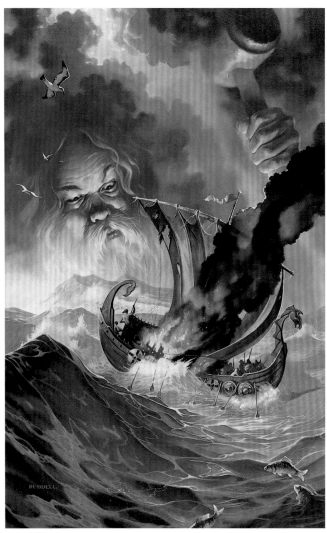

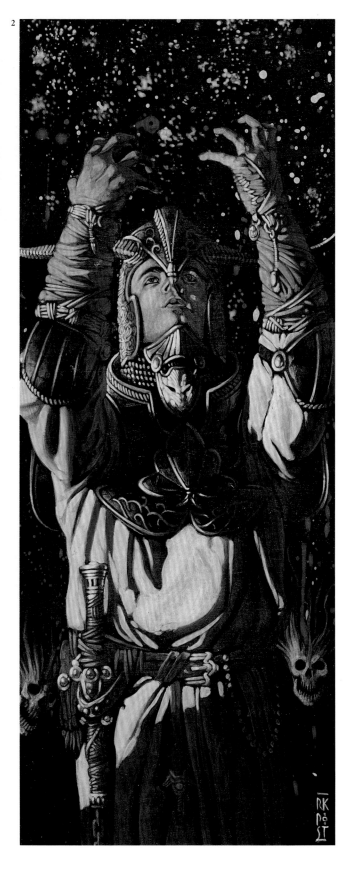

1
artist: **GARY RUDDELL**
art director: Irene Gallo
designer: Gary Ruddell
client: Tor Books
title: The King & The Emperor
medium: Oil
size: 18"x24"

2
artist: **R.K. POST**
art director: Stephen Daniele
client: TSR
title: Scary Andy
medium: Acrylic
size: 4"x10"

3
artist: **ROMAS**
art director: Maria Melilli
client: Tor Books
title: Spear of Heaven
medium: Acrylic & oil
size: 22"x30"

3

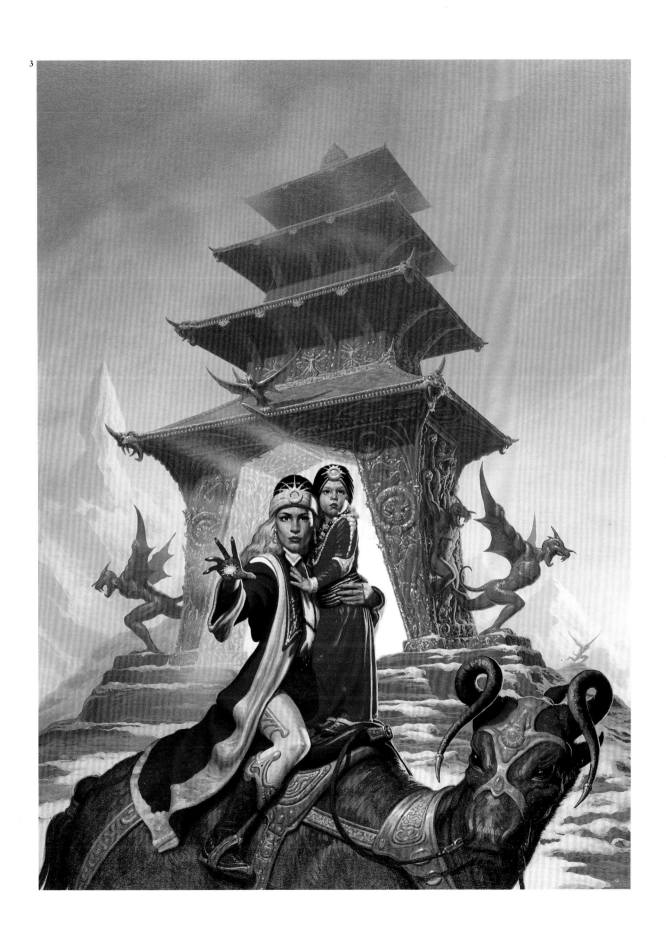

1

artist: **RICHARD POWERS**
client: Easton Press
title: Flowers for Algernon
medium: Acrylic
size: 18"x24"

2

artist: **PAUL YOULL**
art director: Jamie Warren Youll
client: Bantam Books/Lucas Films
title: X-Wing: Wedge's Gamble
medium: Acrylic & oil
size: 380mmx610mm

3

artist: **JIM BURNS**
art director: John Munday
client: HarperCollins
title: Seasons of Plenty
medium: Acrylic on board
size: 32"x22"

4

artist: **DAVID B. MATTINGLY**
art director: Jim Baen
designer: David B. Mattingly
client: Baen Books
title: Honor Among Enemies
medium: Digital

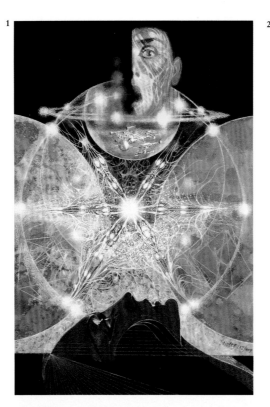

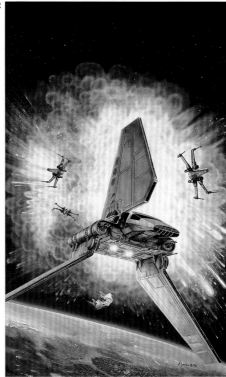

4

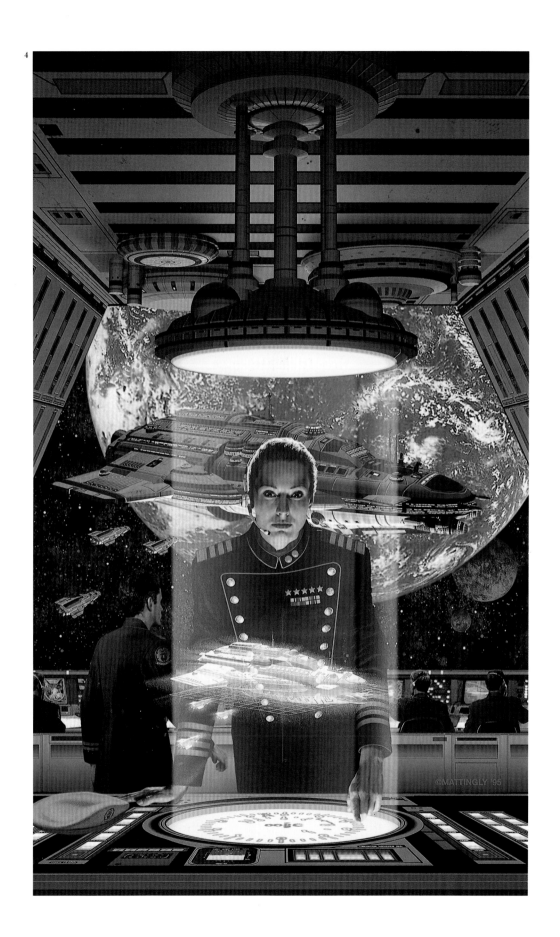

©MATTINGLY '95

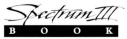

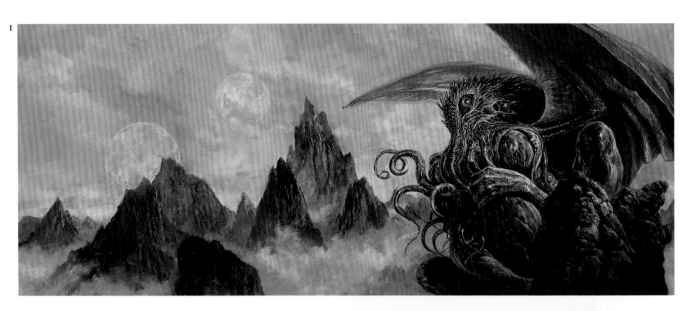

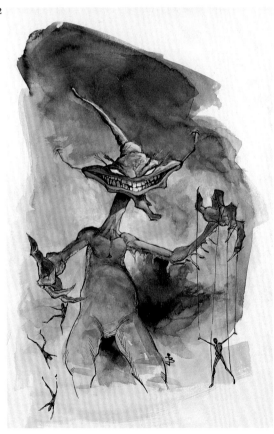

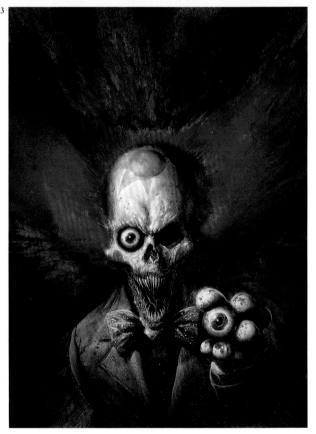

1	2	3	4
artist: **BOB EGGLETON**	*artist:* **JOEL BISKE**	*artist:* **BOB EGGLETON**	*artist:* **JOEL BISKE**
art director: Bob Eggleton	*art director:* Jim Nelson	*designer:* Nick May	*art director:* Jim Nelson
designer: Jim Turner	*client:* FASA Corporation	*client:* Gollancz	*client:* FASA Corporation
client: Arkham House	*title:* Joie's Playthings	*title:* Keepin' An Eye Out For Ya	*title:* Yrsthgrathe
title: Cthulhu 2000	*medium:* Ink wash	*medium:* Acrylic	*medium:* Scratchboard
medium: Gouache	*size:* 7"x10"	*size:* 16"x20"	*size:* 11"x16"
size: 12"x25"			

4

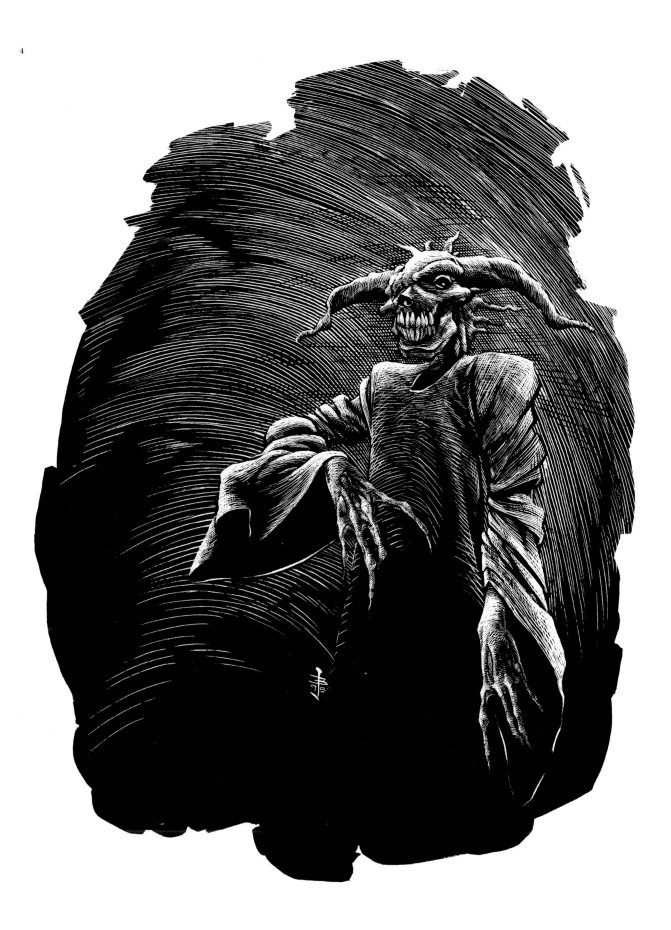

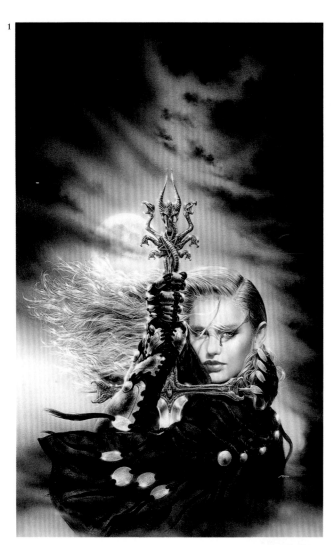

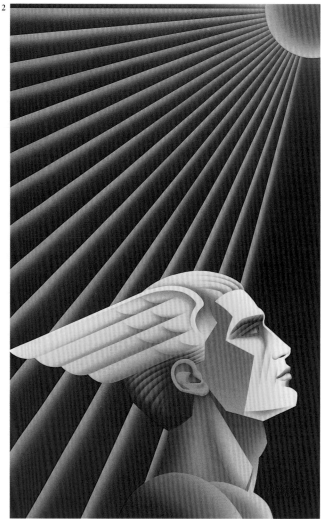

1
artist: **LUIS ROYO**
art director: Luis Royo
client: Norma Editorial
title: Malefic
medium: Acrylic & ink
size: 14"x18"

2
artist: **NICK GAETANO**
art director: George Cornell
client: Penguin U.S.A.
title: Mercury
medium: Acrylic & airbrush
size: 18"x28"

3
artist: **BRIAN DURFEE**
art director: Brian Durfee
designer: Larry Smith
client: TSR
title: Character Creation
medium: Acrylic
size: 19"x29"

4
artist: **RICHARD BOBER**
art director: Irene Gallo
designer: Richard Bober
client: Tor Books
title: Shards of the Empire
medium: Oil
size: 24"x30"

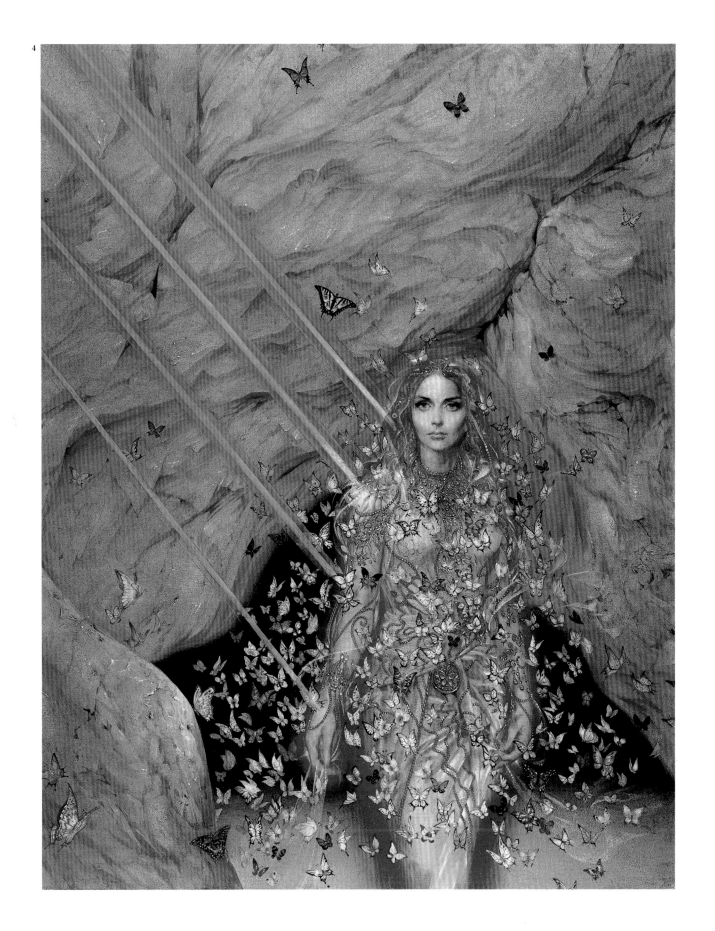

4

1
artist: **DOUG ANDERSON**
art director: Jim Nelson
client: FASA Corporation
title: Corporate Security
medium: Oil
size: 18"x18"

2
artist: **STEPHEN YOULL**
art director: Jamie S. Warren
designer: Stephen Youll
client: Bantam Books
title: Tales from Jabba's Palace
medium: Oil
size: 28"x22"

3
artist: **PAUL R. ALEXANDER**
art director: Jim Baen
client: Baen Books
title: The Triumphant
medium: Gouache
size: 15"x24"

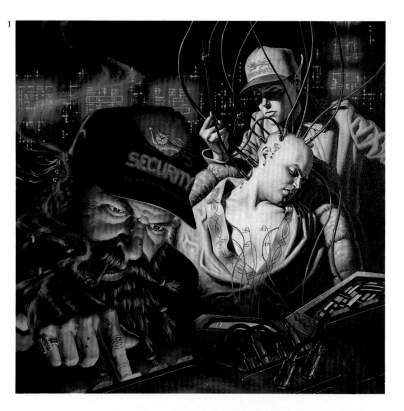

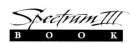

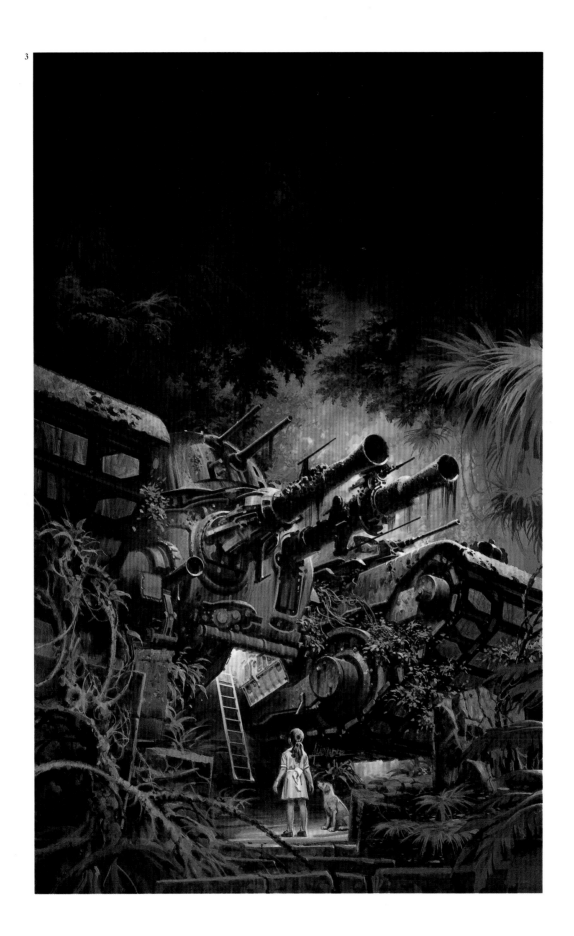

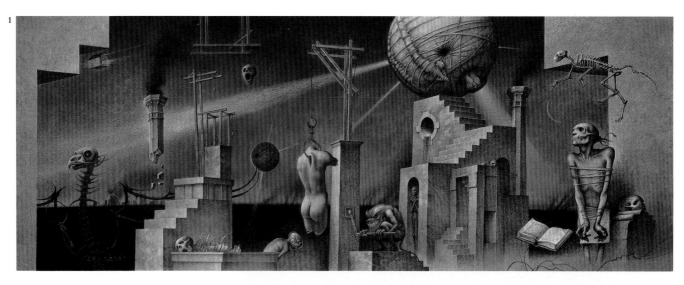

1
artist: **JOHN JUDE PALENCAR**
art director: David Stevenson
designer: David Stevenson &
 John Jude Palencar
client: Ballantine Books
title: The Dream Cycles of H.P. Lovecraft:
 Dream of Terror & Death
medium: Acrylic
size: 40"x15¾"

2
artist: **ALAN M. CLARK**
client: Blue Moon Books
title: Chuckling Beneath His Mask
medium: Acrylic
size: 18"x22"

3
artist: **JOSEPH DeVITO**
art director: Joseph DeVito
designer: Joseph DeVito
client: Tor Books
title: Vanitas
medium: Oil
size: 12½"x17½"

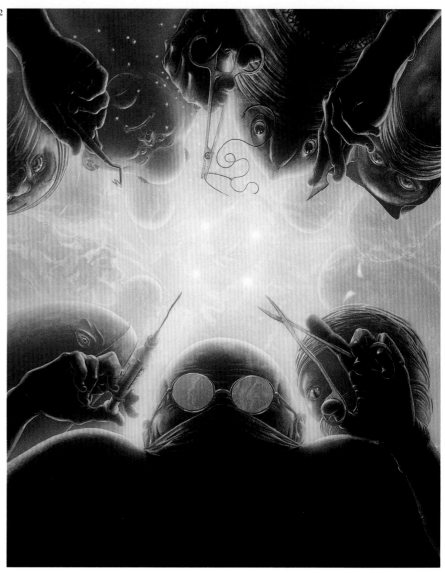

3

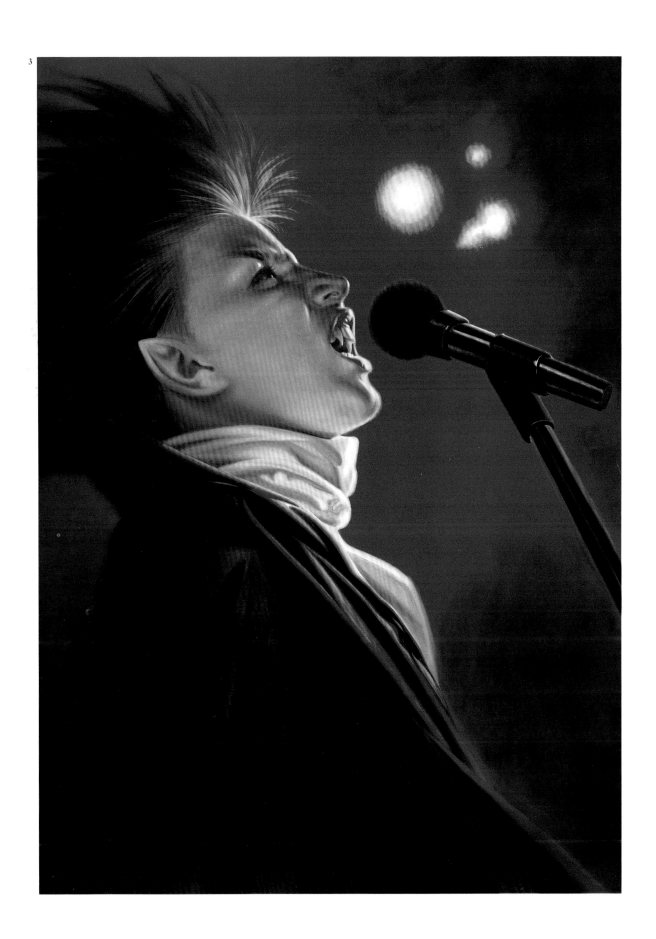

1

artist: **GLEN ORBIK**
art director: Peggy Cooper
client: TSR, Inc.
title: Tales of Enchantment
medium: Oil
size: 29"x35"

2

artist: **DONATO GIANCOLA**
art director: Jerry Todd
client: Roc/Penguin U.S.A.
title: Caverns of Socrates
medium: Oil on paper
size: 34"x22"

3

artist: **STEPHEN YOULL**
art director: Jamie S. Warren
designer: Stephen Youll
client: Bantam Books
title: Exile's Children
medium: Oil
size: 30"x40"

1

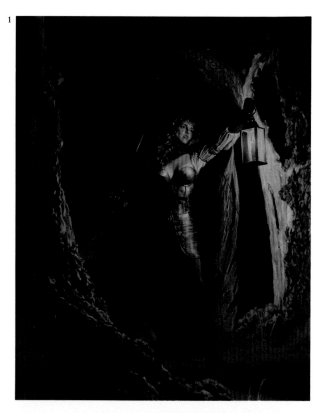

2

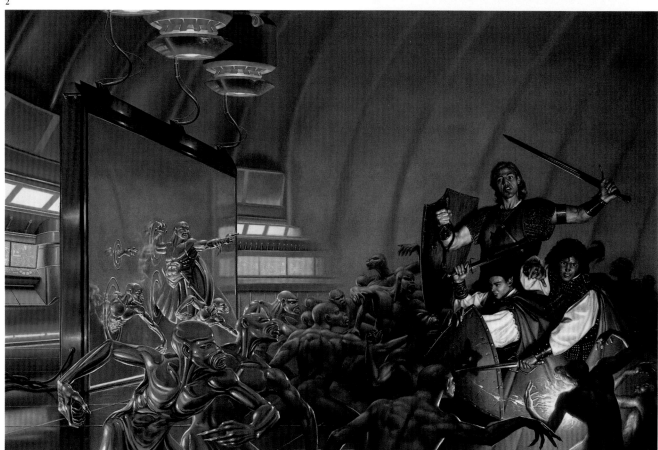

3

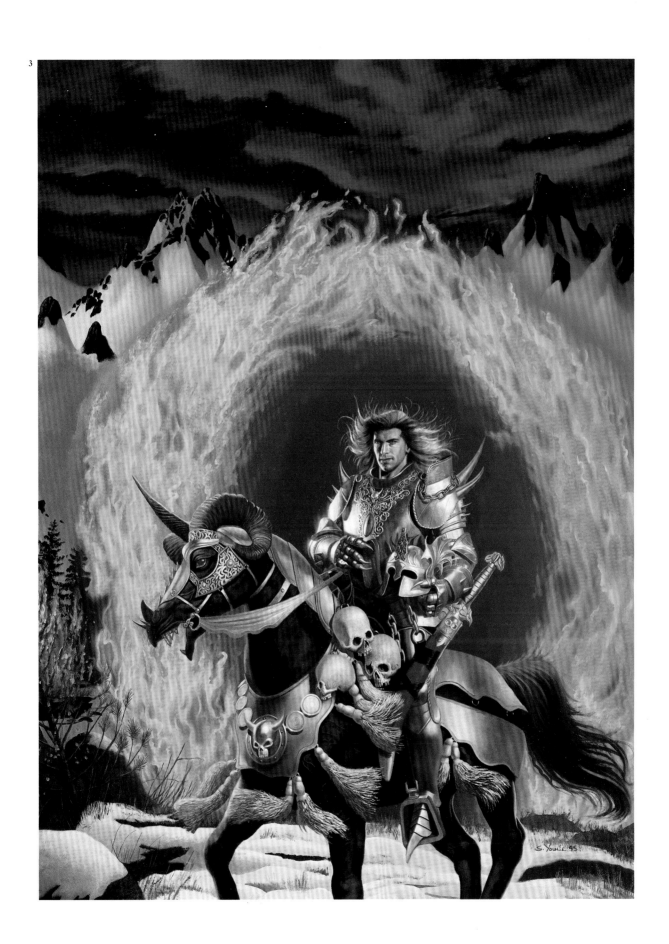

1
artist: **PAUL R. ALEXANDER**
art director: Jim Baen
client: Baen Books
title: Allies & Aliens
medium: Gouache
size: 14½"x23"

2
artist: **BRUCE JENSEN**
art director: Irene Gallo
designer: Richard Etienne
client: Tor Books
title: Armed Memory
medium: Acrylic
size: 16"x24"

3
artist: **BRYN BARNARD**
art director: Jeff Brenner
client: Putnam Publishing
title: Dune
medium: Oil
size: 18"x24"

4
artist: **DARREL ANDERSON**
art director: Jim Nelson
client: FASA Corporation
title: O'Sapiens Music Box
medium: Digital

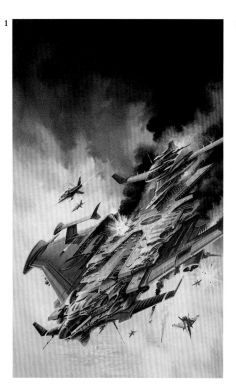

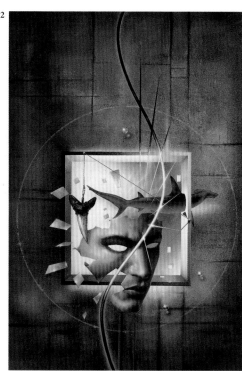

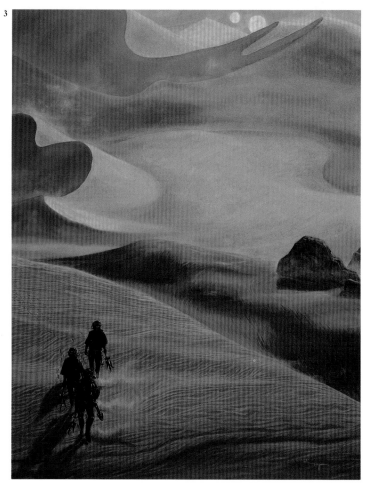

4

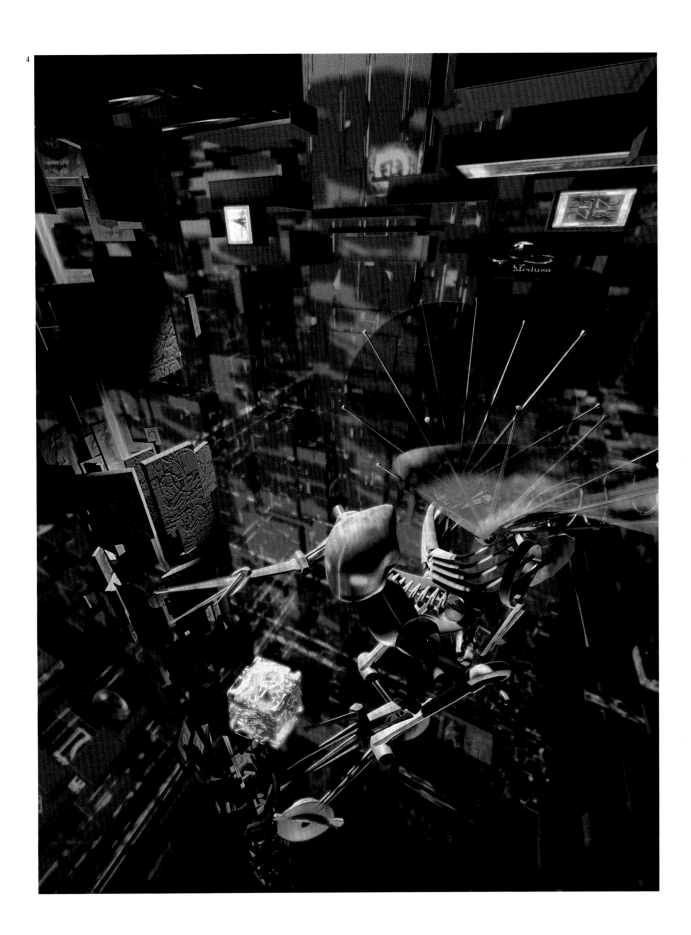

1
artist: **PAT MORRISSEY**
art director: Joe Rapoli
client: Easton Press
title: Fisherman of the Inland Sea
medium: Acrylic & oil
size: 18"x24"

2
artist: **ROMAS**
art director: Carl Galian
client: Penguin U.S.A.
title: Arcady
medium: Acrylic
size: 22½"x30"

3
artist: **MICHAEL WHELAN**
art director: Sheila Gilbert
client: DAW Books
title: Exiles II: Spellweaver
medium: Acrylic & watercolor on board
size: 22"x30"

1
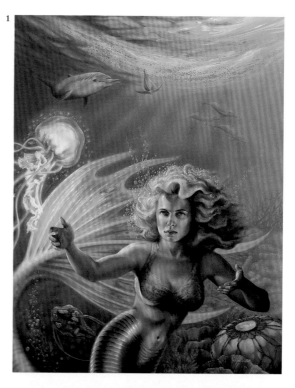

2
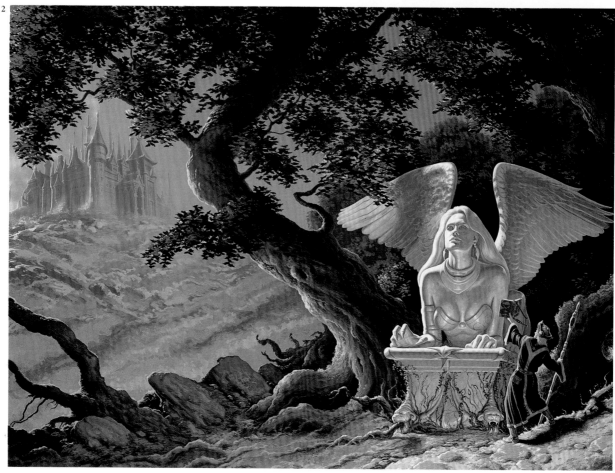

3

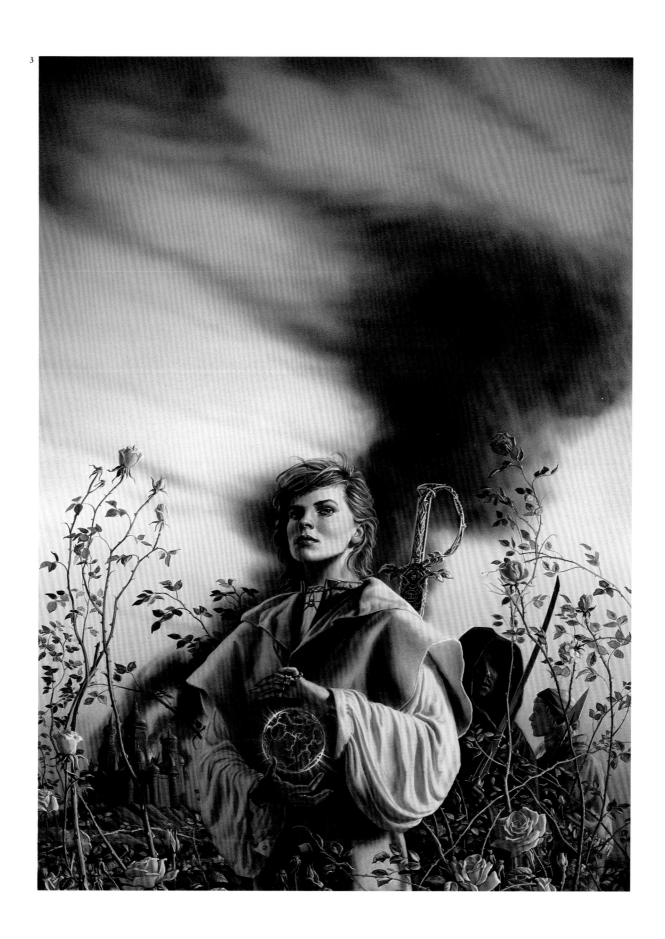

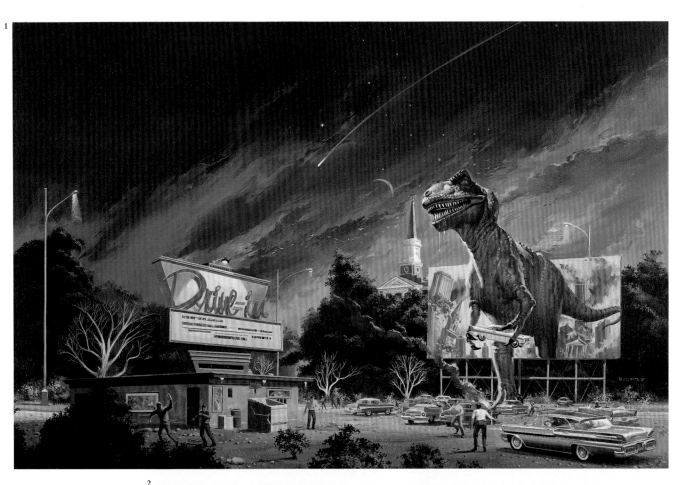

1
artist: **VINCENT DiFATE**
art director: Sheila Gilbert
client: DAW Books
title: It Came From
 the Drive-In
medium: Acrylic on board
size: 18"x24"

2
artist: **ROMAS**
art director: George Cornell
client: Penguin U.S.A.
title: Grunts
medium: Acrylic
size: 22"x30"

3
artist: **RON WALOTSKY**
art director: Mike Anderson
client: Thorndike,Hall Press
title: 2001 Anniversary
medium: Acrylic

4
artist: **ROB WOOD**
art director: Neil Stuart
client: Penguin U.S.A.
title: The Weatherman
medium: Acrylic on board
size: 10"x17"

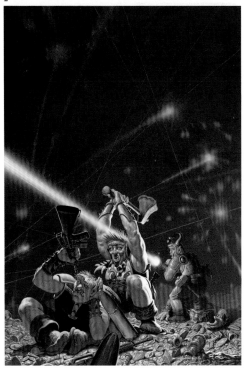

4

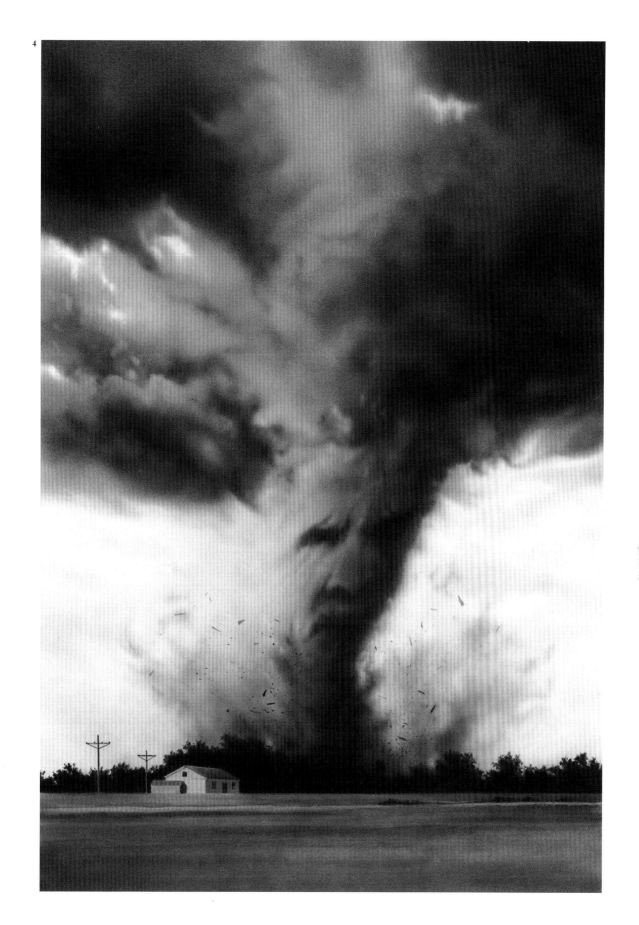

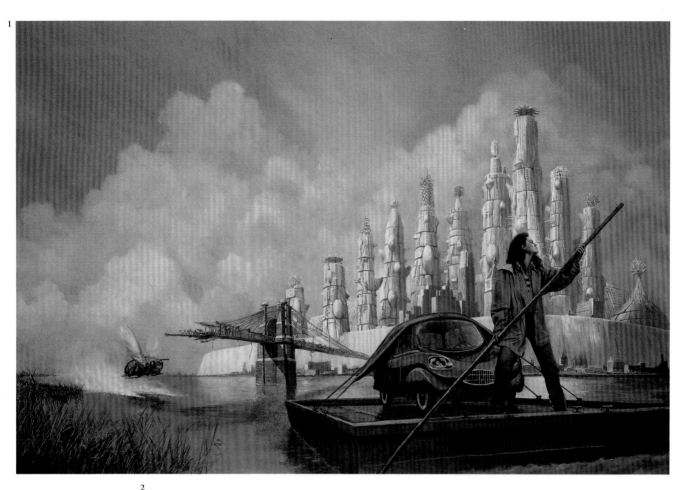

1

artist: **NICHOLAS JAINSCHIGG**
art director: Irene Gallo
designer: Carol Russo
client: Tor Books
title: Queen City Jazz
medium: Acrylic & oil
size: 36"x24"

2

artist: **DiTERLIZZI**
art director: Peggy Cooper
designer: Dawn Murin
client: TSR, Inc.
title: Cat Lord
medium: Ink & watercolor
size: 11"x14"

3

artist: **KEVIN KRENECK**
art director: Kevin Kreneck
client: Graphis
title: Counting Sheep
medium: Pen & ink
size: 6H"x10"

4

artist: **MIKE WIMMER**
client: Hyperion
title: Thunder Cave

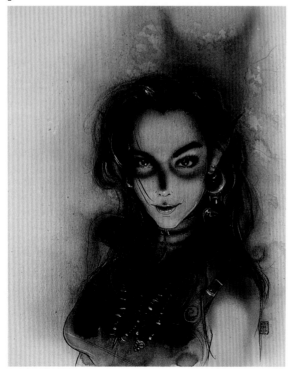

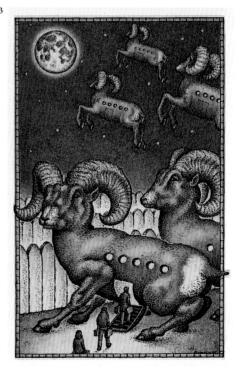

4

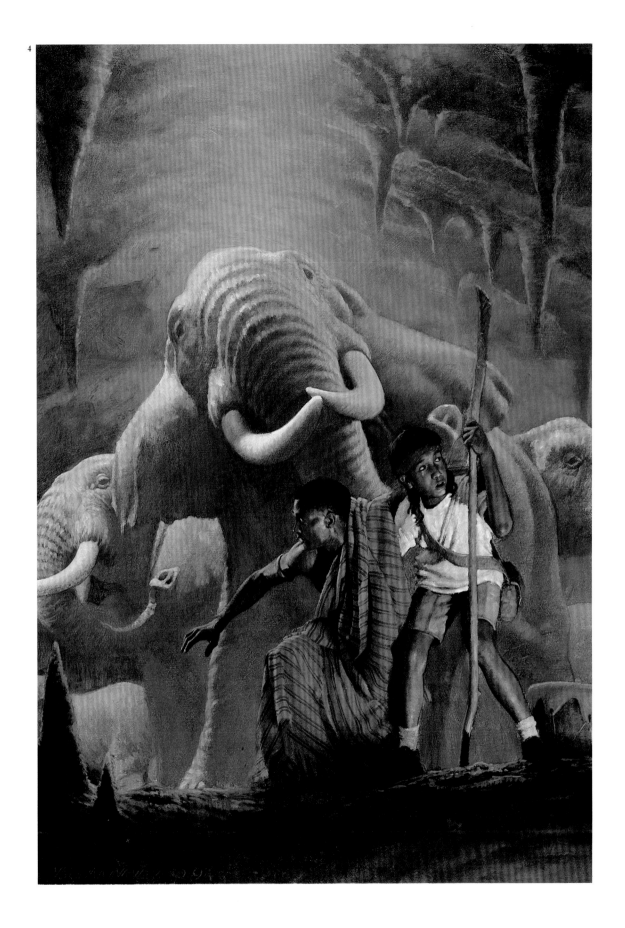

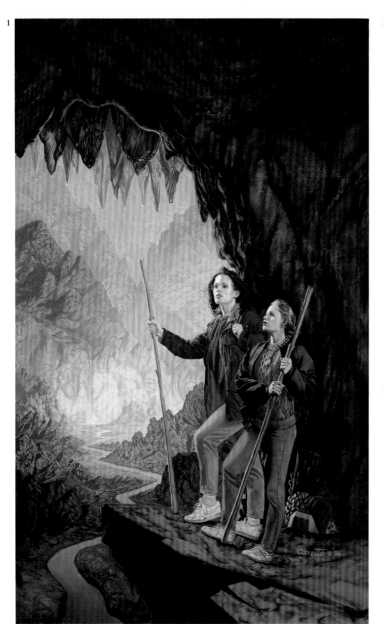

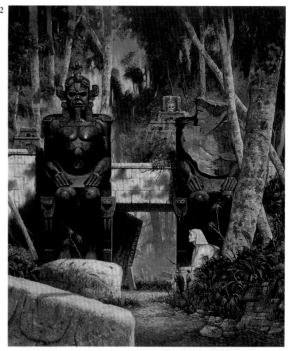

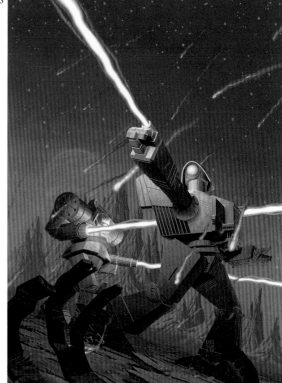

1
artist: **DON CLAVETTE**
art director: Judith Murello
client: Berkley Publishing Group
title: Troll Quest
medium: Oil
size: 18"x30"

2
artist: **LES EDWARDS**
art director: Jim Nelson
designer: Jim Nelson
client: FASA Corporation
title: The Book of Exploration
medium: Oil
size: 18"x22"

3
artist: **LES DORSCHEID**
art director: Jim Nelson
designer: Les Dorscheid
client: FASA Corporation
title: Chaos March
medium: Oil
size: 20"x28"

4
artist: **JOHN ZELEZNIK**
art director: Kevin Siembieda
designer: John Zeleznik
client: Palladium Books, Inc.
title: Rifts Underseas
medium: Acrylic
size: 18"x22"

4

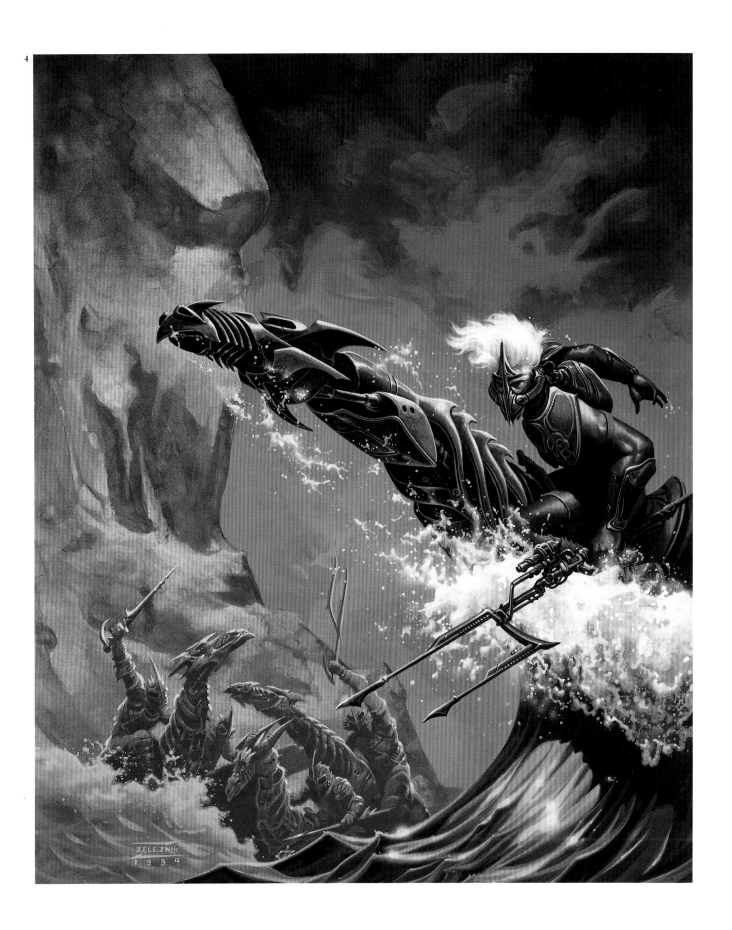

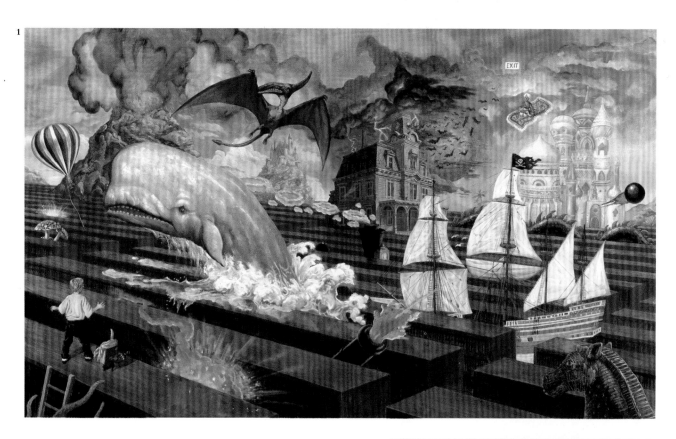

1
artist: **JERRY TIRITILLI**
art director: Michael Walsh
designer: Michael Walsh
client: Turner Publishing
title: The Pagemaster

2
artist: **NICK GAETANO**
art director: George Cornell
client: Penguin U.S.A.
title: Icarus
medium: Acrylic & airbrush
size: 18"x28"

3
artist: **DARREL ANDERSON**
art director: Jim Nelson
client: FASA Corporation
title: OrnoSapien Plan
medium: Digital

4
artist: **JANNY WURTS**
art director: Gene Mydlowski
client: HarperCollins
title: Keeper of the Keys
medium: Oil
size: 30"x22½"

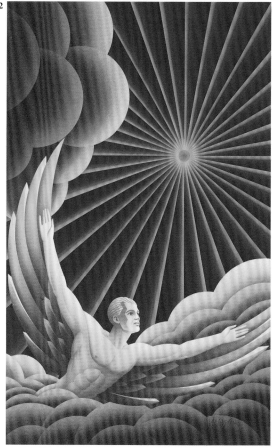

3

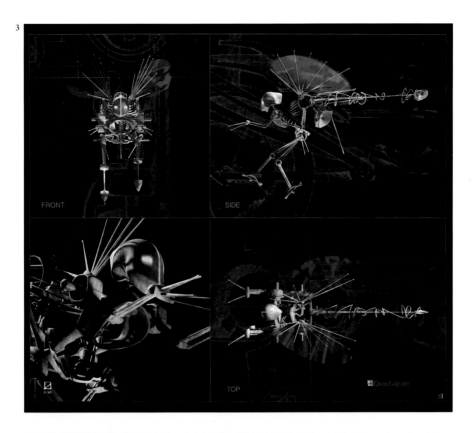

4

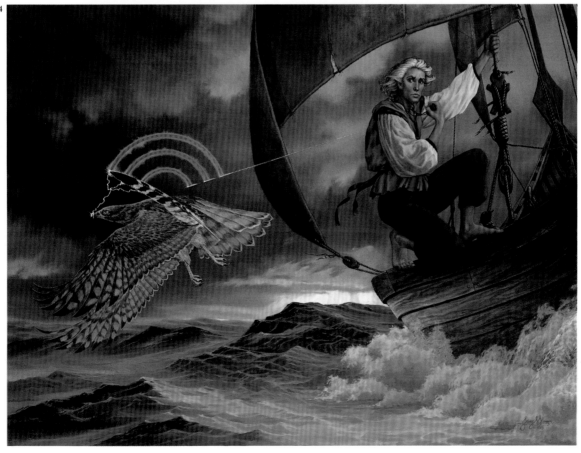

1
artist: **DOUG BEEKMAN**
art director: Irene Gallo
client: Tor Books
title: Wizard's First Rule
medium: Oil
size: 24"x39"

2
artist: **JEFF MIRACOLA**
art director: Jim Nelson
designer: Jim Nelson
client: FASA Corporation
title: Bone Crown
medium: Oil on masonite
size: 18"x24"

3
artist: **JOHN HOWE**
art director: Sheila Gilbert
designer: Miles Long
client: DAW Books
title: Castle Fantastic
medium: Watercolor
size: 18"x24"

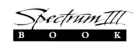

3

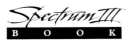

1
artist: **IAN MILLER**
client: Pan
title: The Cygnet & the Firebird
medium: Acrylic
size: 11"x15½"

2
artist: **BROM**
art director: Jim Nelson
designer: Jim Nelson
client: FASA Corporation
title: Warbird
medium: Oil
size: 17"x23"

3
artist: **LES EDWARDS**
art director: Mike Stocks
designer: Mike Stocks
client: Usborne Publishing
title: Victorian Ghost Stories:
 The Open Door
medium: Oil
size: 10"x16"

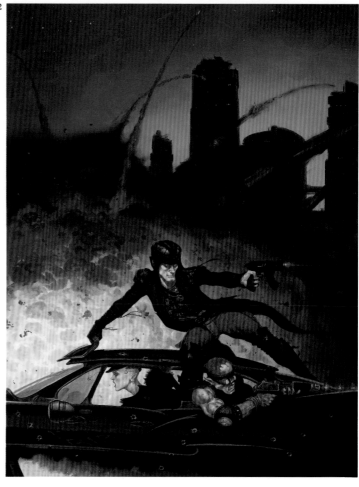

3

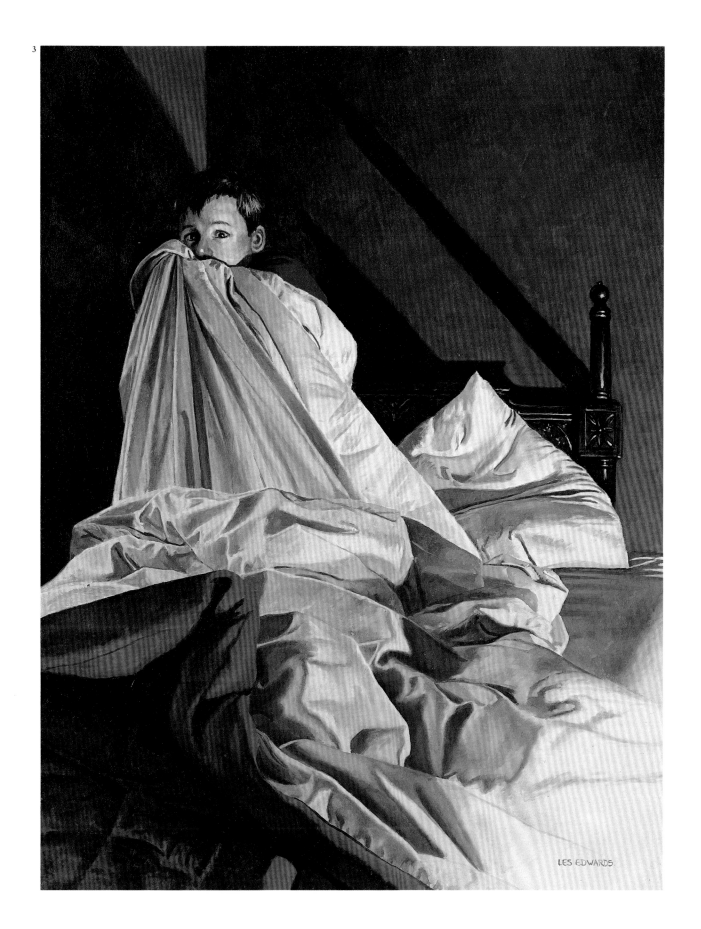

1
artist: **ROMAS**
art director: George Cornell
client: Penguin U.S.A.
title: The Catswold Portal
medium: Acrylic
size: 29"x22"

2
artist: **DONATO GIANCOLA**
art director: Carl Galian
client: Roc/Penguin U.S.A.
title: Eggheads
medium: Oil on paper
size: 15"x26"

3
artist: **TARA McGOVERN**
art director: Judith Murello
designer: Judith Murello
client: Berkley Publishing
title: Resurrection Man
medium: Acrylic
size: 30"x40"

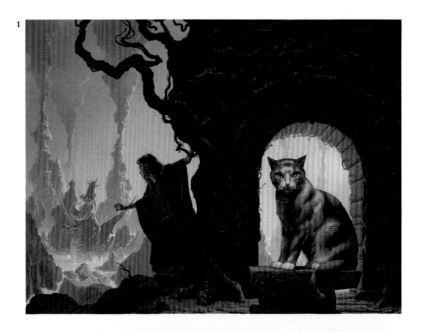

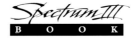

3

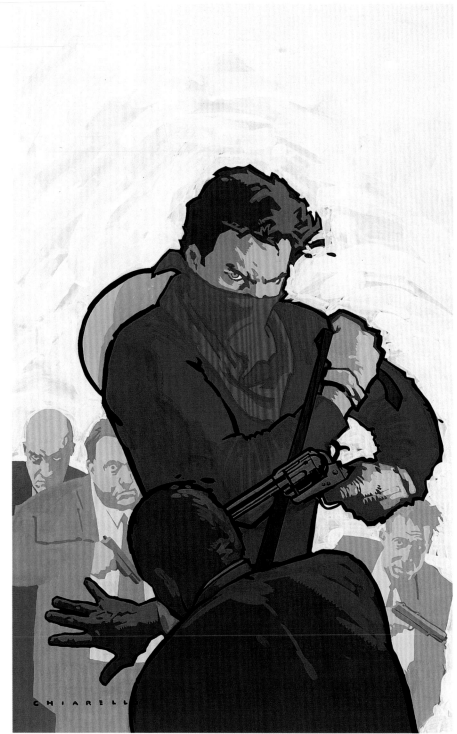

Vigilante copyright © and TM 1996 D.C. Comics

artist: **MARK CHIARELLO**
art director: Archie Goodwin/Chris Duffy
client: D.C. Comics
title: Vigilante #1
medium: Gouache
size: 11"x17"

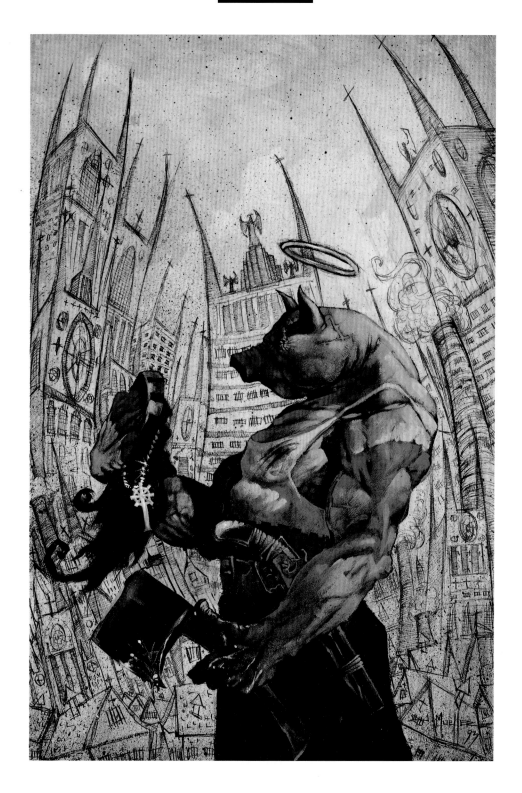

artist: **JOHN MUELLER**
art director: Annie Brockway
designer: Kevin Lison
client: Kitchen Sink Press
title: Oink #1

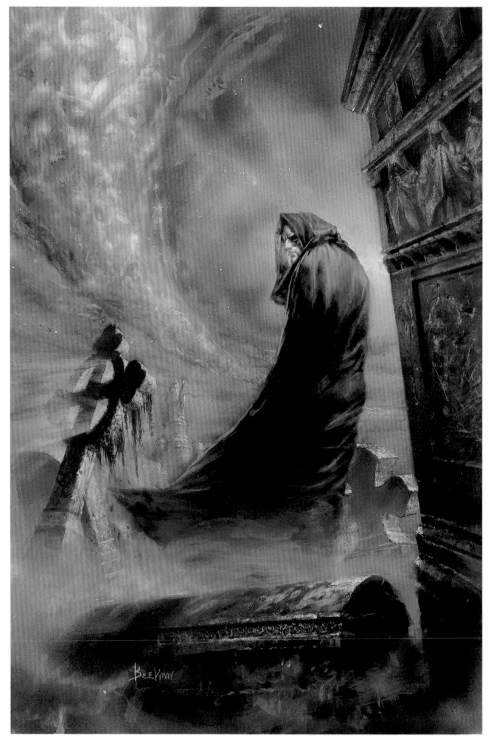

The Spectre copyright © and TM 1996 D.C. Comics.

artist: **DOUG BEEKMAN**
art director: Dan Raspler/Mark Chiarello
client: D.C. Comics
title: Phantasm of Eternity
medium: Oil & acrylic on board
size: 20"x30"

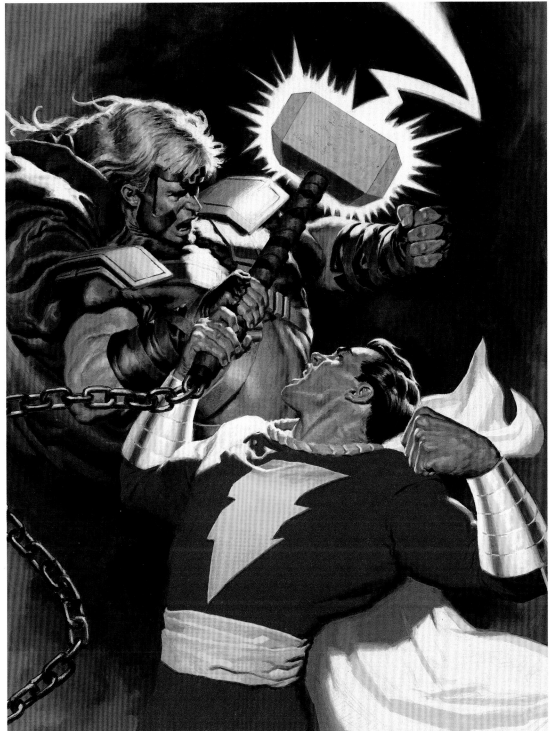

Thor copyright © and TM 1996 Marvel Comics. Captain Marvel copyright © and TM 1996 D.C. Comics.

artists: **GLEN ORBIK, LAUREL BLECHMAN,
& SHAWN ZENTS**
art director: Jim Spivey
client: D.C. Comics
title: Thor VS Captain Marvel
medium: Gouache
size: 12"x16½"

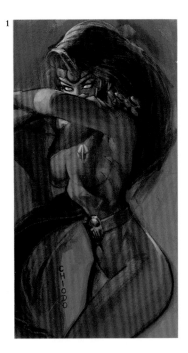

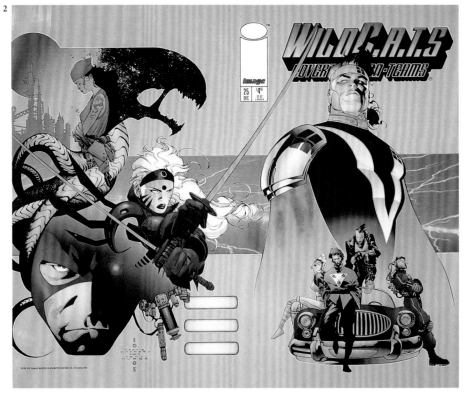

1
artist: **JOE CHIODO**
art director: Ted Adams
client: Wildstorm Productions
title: Voodoo
medium: Acrylic
size: 8½"x11½"

2
artist: **TRAVIS CHAREST**
 & TROY HUBBS
art director: Mike Heisler
designer: Travis Charest
client: Wildstorm Productions
title: Wildcats: Covert Action Teams #25
medium: Colored inks
size: 22"x17"

3
artist: **CHRIS WARE**
art director: Monte Beauchamp
designer: Chris Ware
client: Kitchen Sink Press
title: Blab #8

4
artist: **JOE CHIODO**
art director: Ted Adams
client: Wildstorm Productions
title: Despot
medium: Acrylic
size: 8½"x11½"

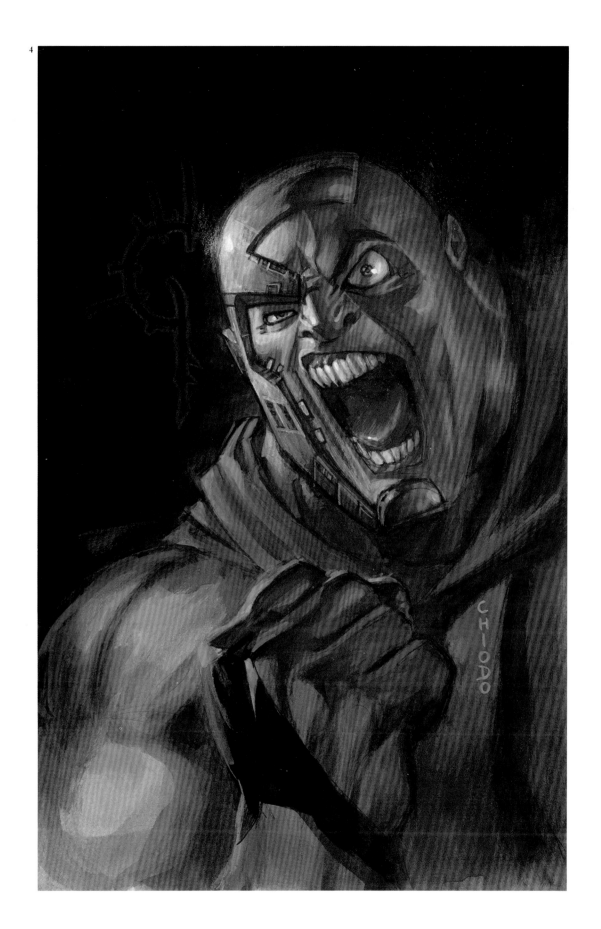

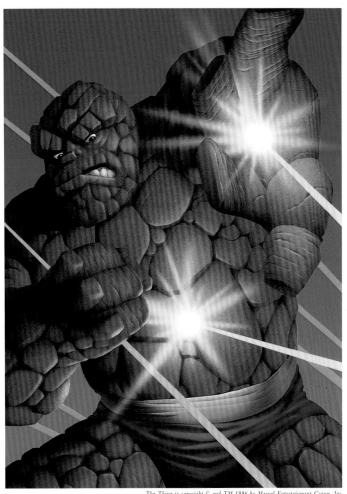

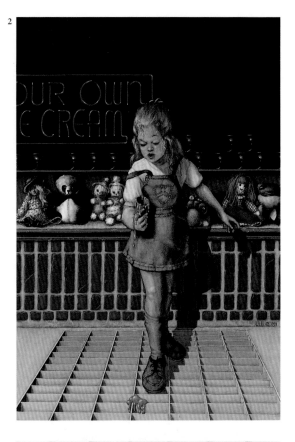

The Thing is copyright © and TM 1996 by Marvel Entertainment Group, Inc.

1
computer artist: **CHUCK MAIDEN**
penciler: Warren Martineck
art director: Mike Giles
client: Marvel Entertainment Group, Inc./
 Fleer Corporation
title: The Thing
medium: Digital

2
artist: **JILL BAUMAN**
designer: Jill Bauman
client: Harlan Ellison/Dark Horse Comics
title: Our Own Ice Cream I & II
medium: Acrylic
size: Each 16"x24"

3
artist: **JOHN C. CEBOLLERO**
client: Event Comics
title: Gabriel
medium: Acrylic
size: 8¼"x12½"

3

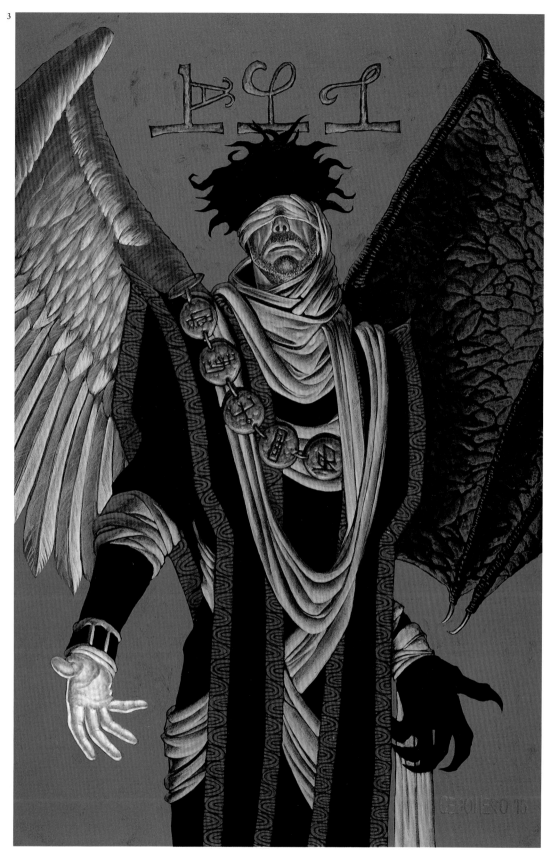

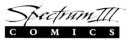

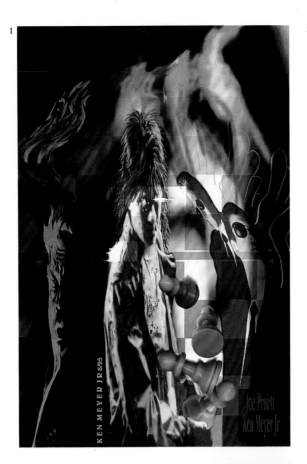

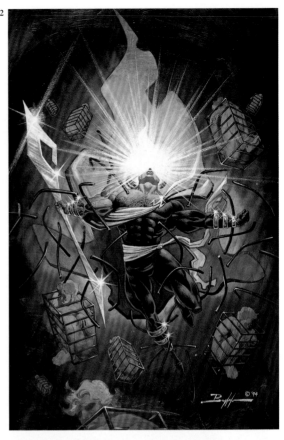

1
artist: **KEN MEYER JR.**
client: Caliber Comics
title: Digitized K
medium: Digital
size: 10"x15"

2
artist: **NORM BREYFOGLE**
client: Norm Breyfogle
publisher: Malibu Comics
title: Metaphysique #1 Cover
medium: Acrylic/mixed
size: 11"x17"

3
artist: **JOHN HANLEY**
art director: Darren Vincenzo/Scott Peterson
client: D.C. Comics
title: Batman Forever Comic Adaptation
medium: Mixed
size: 40"x30"

4
artist: **DON MAITZ**
art director: Robin Brosterman
designer: Don Maitz
client: D.C. Comics
title: Batman: The Last Angel
medium: Oil on masonite
size: 20"x30"

Batman and supporting characters are copyright © and TM 1996 by D.C. Comics.

4

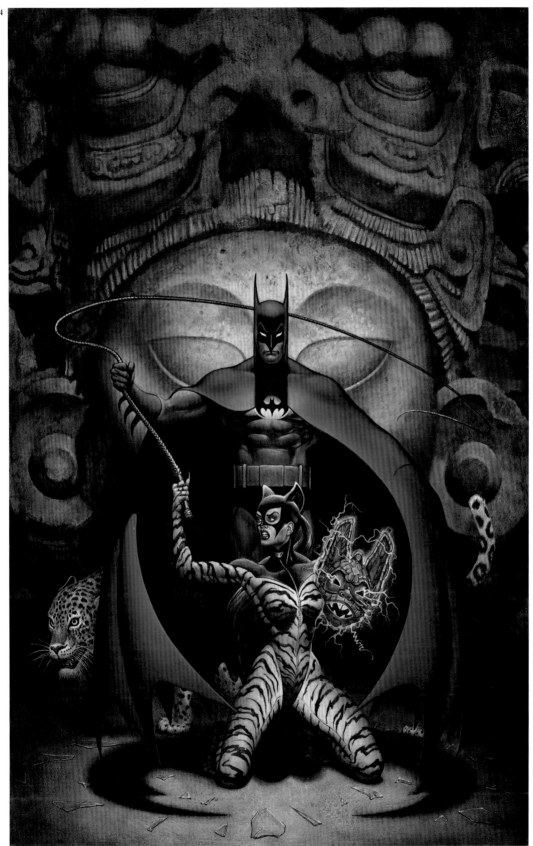

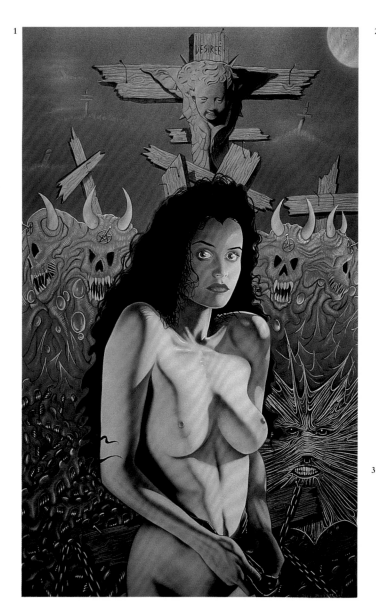

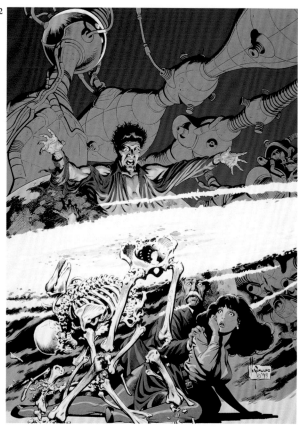

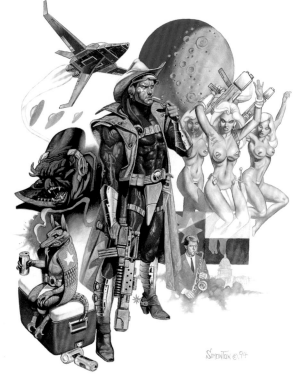

1
artist: **JEFF PITTARELLI**
art director: Daniel Presedo
designer: Dramenon Productions
client: Gothic/Dramenon Studios
title: Dream Wolves
 Swimsuit Bizarre #0
medium: Acrylic & colored pencil
size: 20"x30"

2
artist: **MARK SCHULTZ**
art director: Amie Brockway
designer: Kevin Lison
colorist: Ray Fehrenbach
client: Kitchen Sink Press
title: Death Rattle #1 Cover
medium: Pen & ink
size: 14"x21"

3
artist: **TOM SIMONTON**
art director: Jim Whiting
client: FantaCo
title: Texoma Red
medium: Oil
size: 15"x21"

4
artist: **CHARLES BURNS**
client: Kitchen Sink Press
title: Black Hole #2 Cover

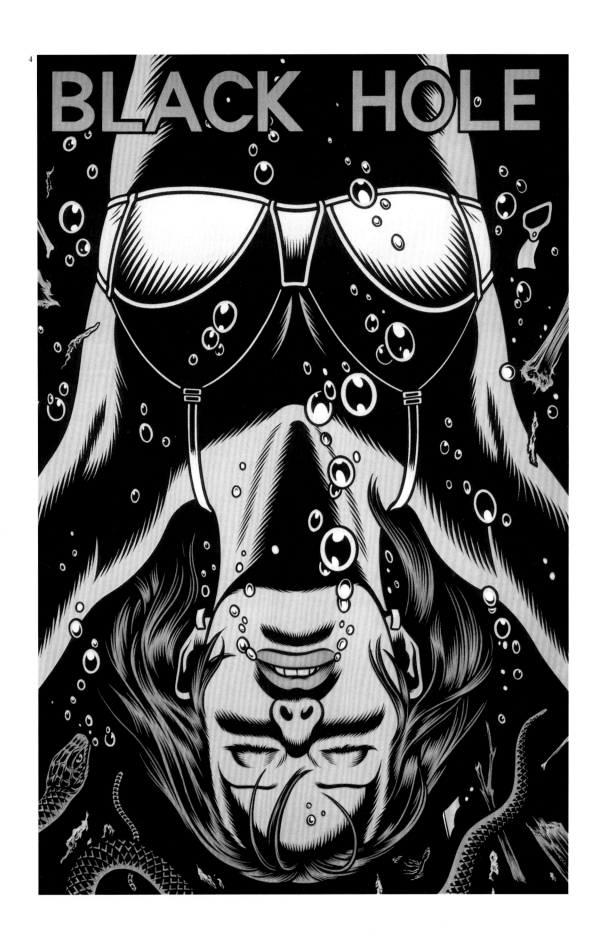

BLACK HOLE

1
artist: **JOE CHIODO**
art director: Ted Adams
client: Wildstorm Productions
title: Grifter
medium: Acrylic
size: 8½"x11½"

2
artist: **CHARLES LANG**
art director: Wendy Snow-Lang
client: Millennium Publications
title: Night's Children:
 Red Trails West #2
medium: Acrylic
size: 16"x20"

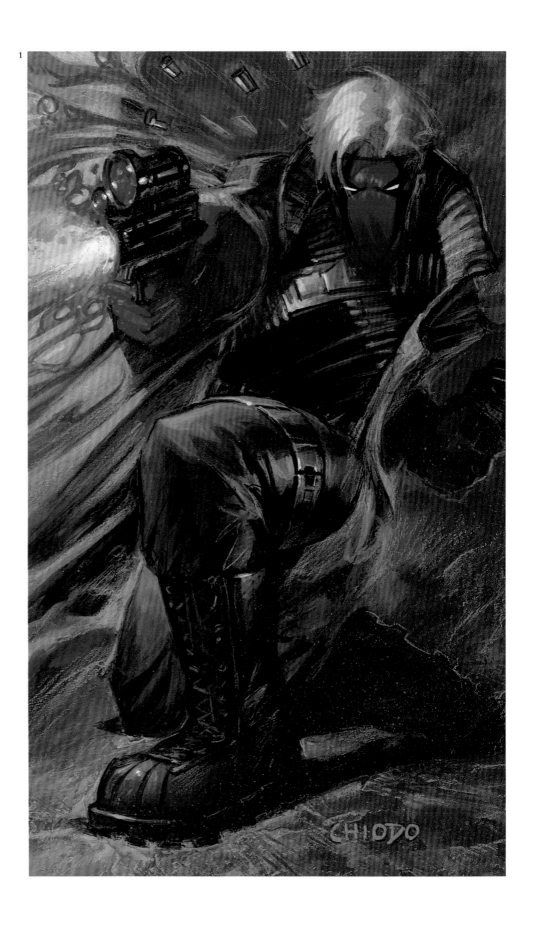

2

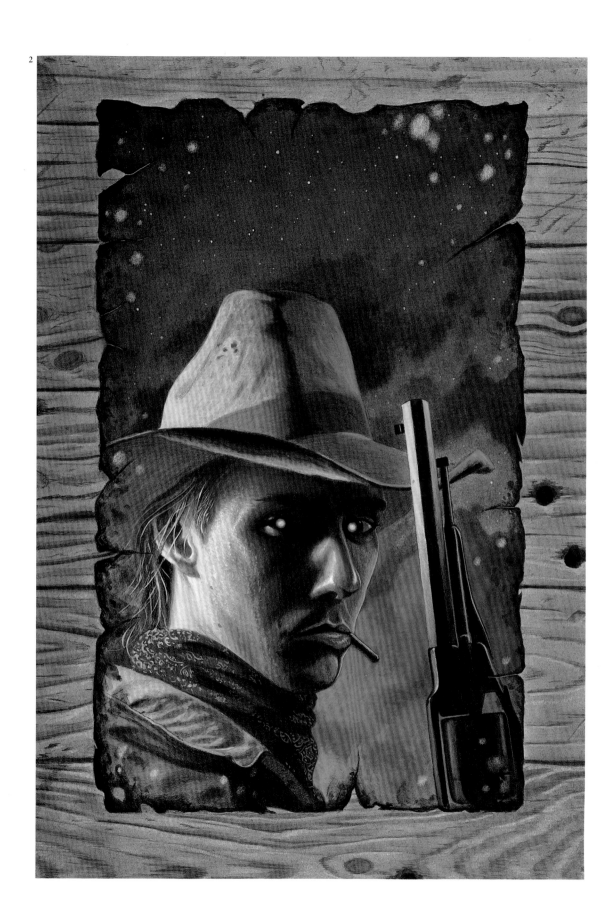

1

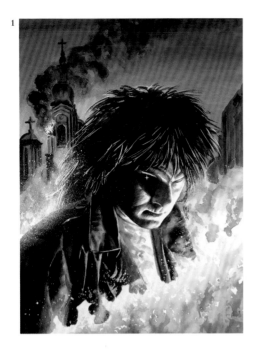

artist: **KEN MEYER JR**
art director: Nate Pride
client: Caliber Comics
title: Kilroy Is Here
medium: Watercolor
size: 10"x15"

2

artist: **STEPHEN HICKMAN**
designer: Stephen Hickman
client: Dark Horse Comics
title: Diver
medium: Oil

3

artist: **JOE CHIODO**
art director: Drew Bittner
computer colorist: Homer Reyes
client: Wildstorm Productions
title: Wetworks
medium: Ink & gouache
size: 20"x30"

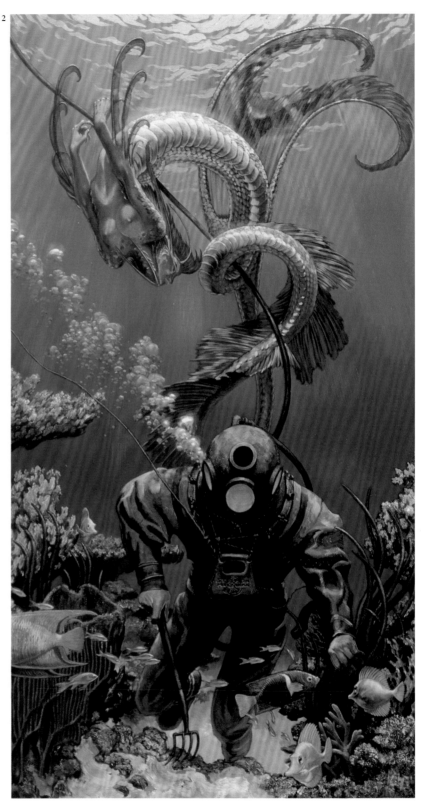

3

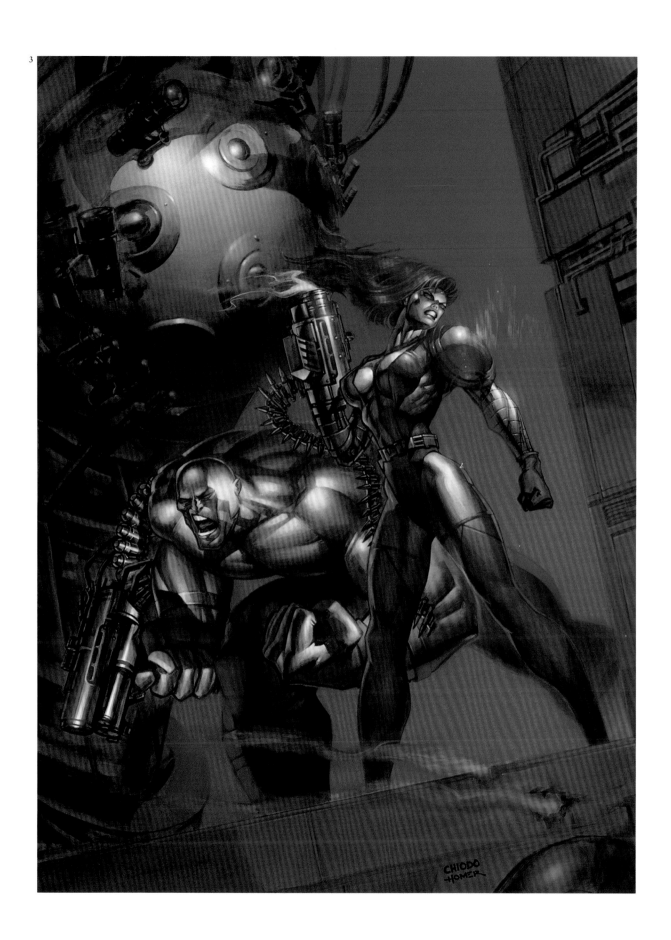

sculptor: **RANDY BOWEN**
designer: Frank Frazetta
client: Dark Horse Comics
title: Death Dealer
medium: Bronze

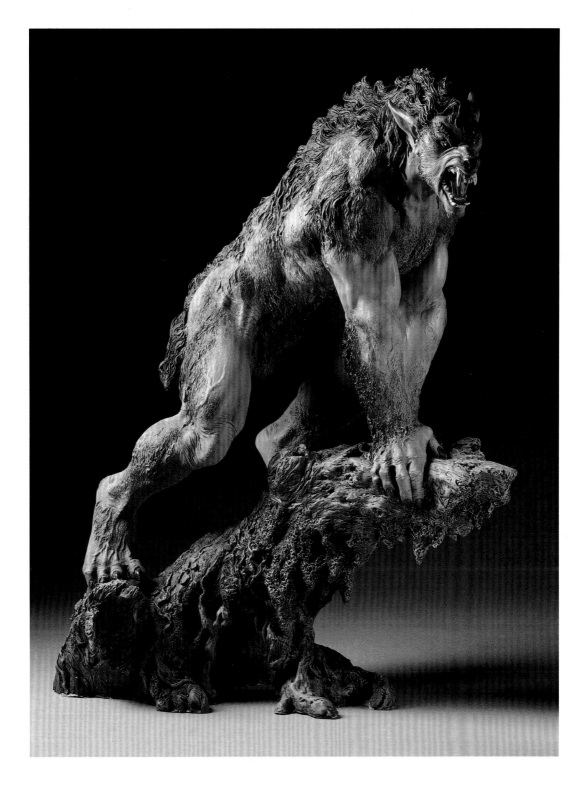

sculptor: **MARK NEWMAN**
art director: Mark Newman
designer: Mark Newman
client: Newmanoid Models
title: Moonsinger
medium: Resin casting
size: 14" tall

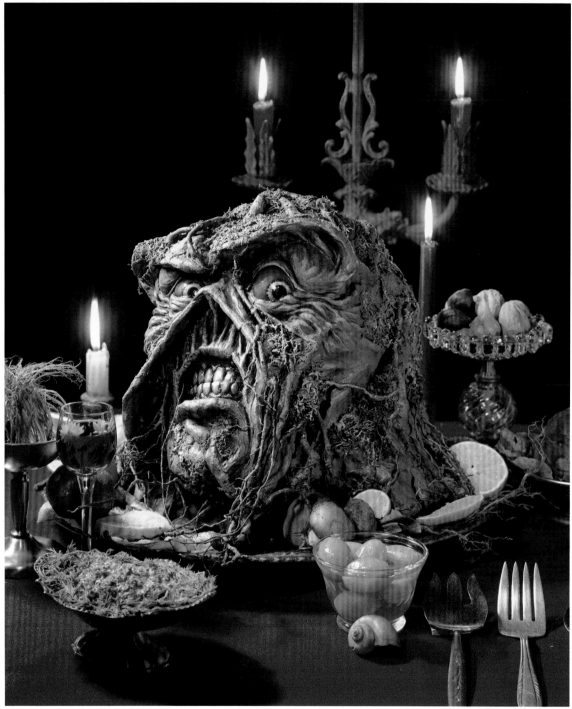

sculptor: **TOM TAGGART**
art director: Stuart Moore
photographer: Sal Trombino
client: D.C. Comics
title: Swamp Thing
medium: Clay

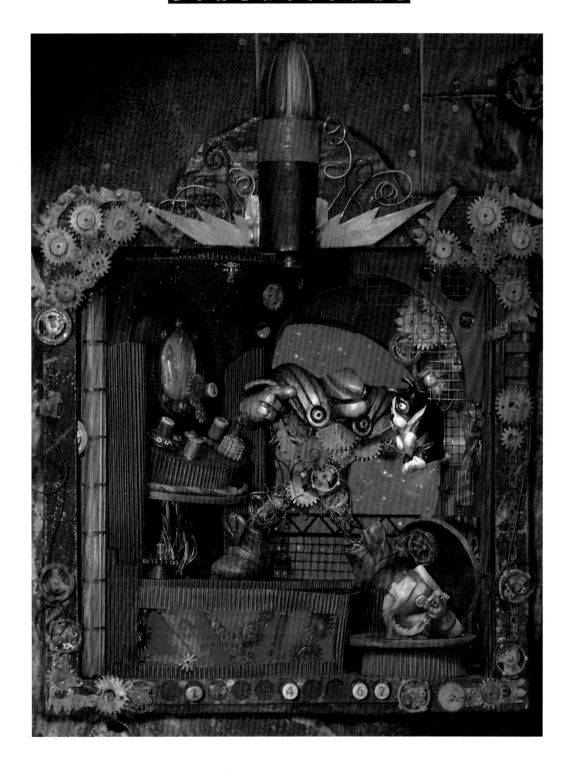

sculptor: **PEDRO MARTIN**
client: Pedro Martin
title: Treasures I
medium: Mixed
size: 14"x14"

1

sculptor: **RANDY BOWEN**
designer: Bowen Design
character creator: R.F. Outcault
client: Gemstone
title: The Yellow Kid
medium: Bronze

2

sculptor: **LISA SNELLINGS**
art director: Lisa Snellings
designer: Lisa Snellings
client: Dark Caravan Series
title: Don't Ask Jack
medium: Clay & wood
size: 17" tall

3

sculptor: **SAMUEL H. GREENWELL**
photographer: Bob Heffner
client: Jayco Hobbies
title: Time Bandit
size: 12" tall

4

sculptor: **CLAYBURN MOORE**
designer: Clayburn Moore
client: Full Bleed
title: Pitt Bronze
medium: Bronze
size: 10½" tall

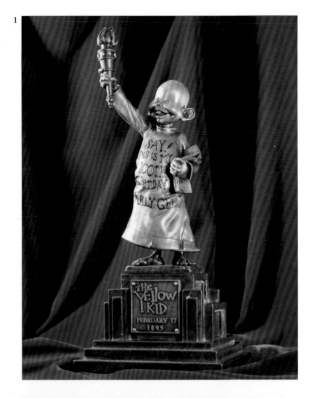

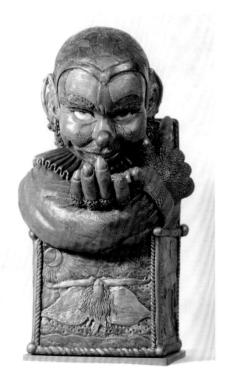

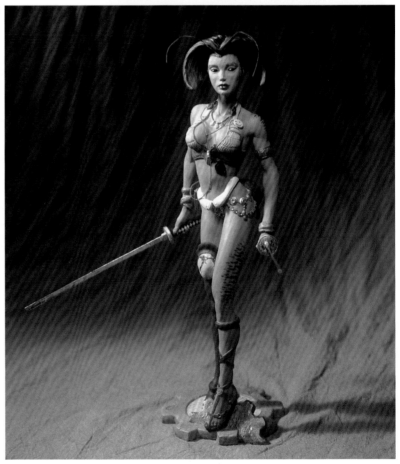

4

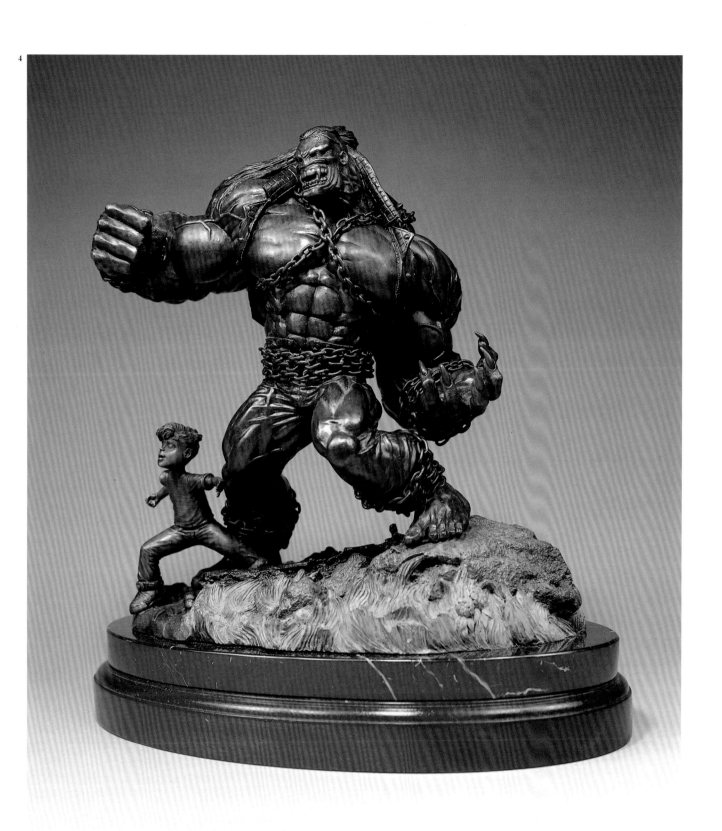

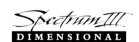

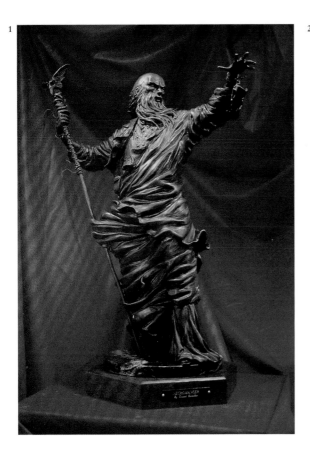

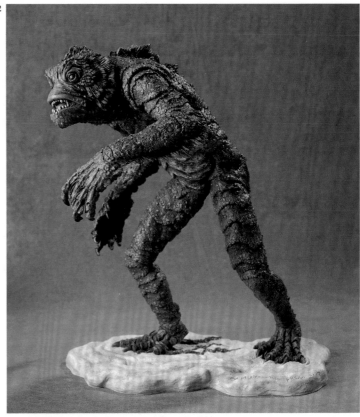

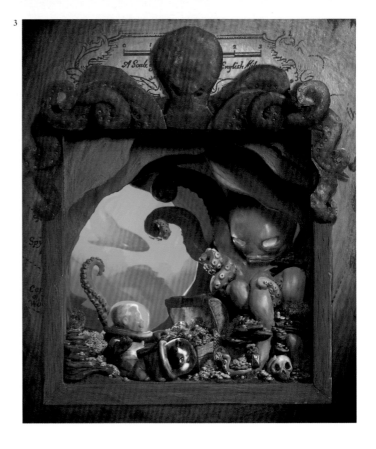

1
sculptor: **VINCENT CANTILON**
title: Stormcrow the Necromancer
medium: Bronze
size: 23" tall

2
sculptor: **TONY McVEY**
title: Gillman (kit)
medium: Cast resin
size: 9" tall

3
sculptor: **PEDRO MARTIN**
client: Pedro Martin
title: Treasures II
medium: Mixed
size: 14"x14"

4
sculptor: **MARK NEWMAN**
art director: Mark Newman
designer: Mark Newman
client: Newmanoid Models
title: Neil Andrythal
medium: Resin casting
size: 10¼" tall

4

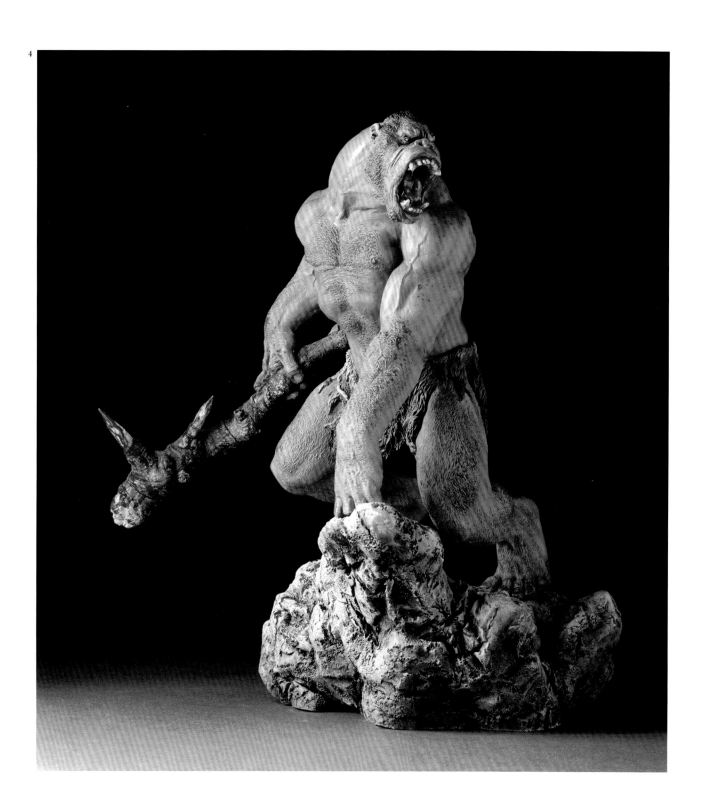

1
sculptor: **TONY McVEY**
title: Juvenile T-Rex
medium: Cast resin
size: 13" wide

2
sculptor: **TONY McVEY**
title: Simple Pleasure
medium: Cast resin
size: 25½" tall

3
sculptor: **RANDY BOWEN**
designer: Michael Wm. Kaluta/Randy Bowen
client: Graphitti Designs
title: The Shadow Bust

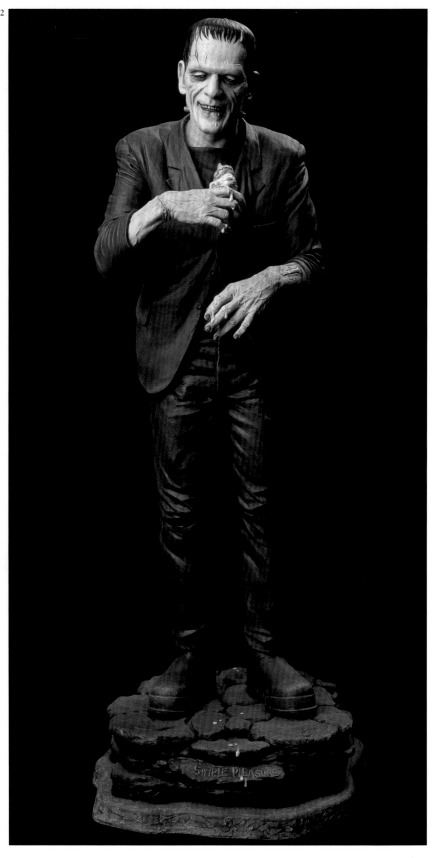

3

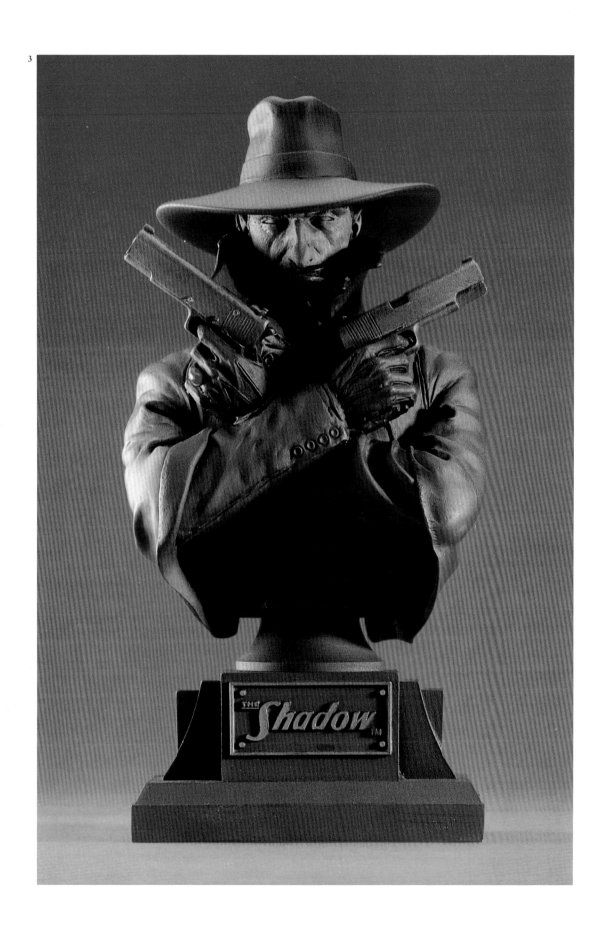

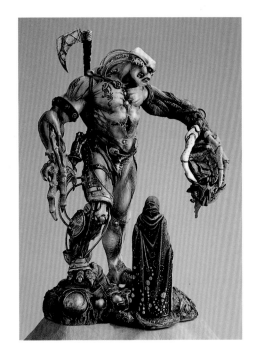

1
sculptor: **RANDY BOWEN**
designer: Randy Bowen
client: Bowen Design
title: The Decapitator

2
sculptor: **CLAYBURN MOORE**
designer: William Tucci/Clayburn Moore
client: William Tucci/Crusade Comics
title: Shi
medium: Polyresin
size: 13" tall

3
sculptor: **STEPHEN HICKMAN**
designer: Stephen Hickman
client: Bowen Design
title: The Call of Cthulhu
medium: Polyform
size: 8" tall

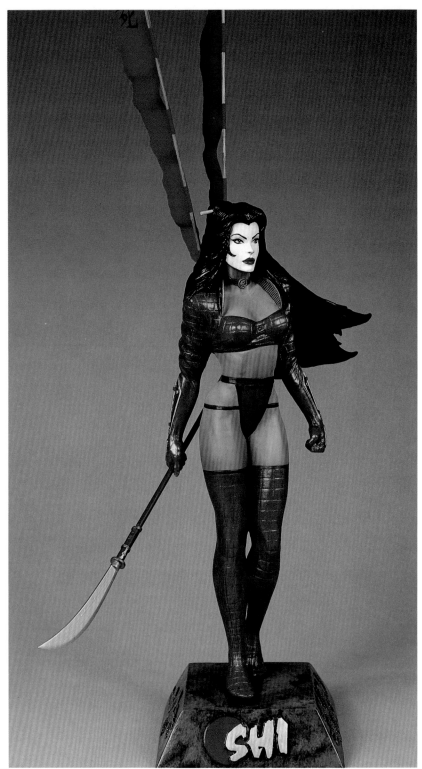

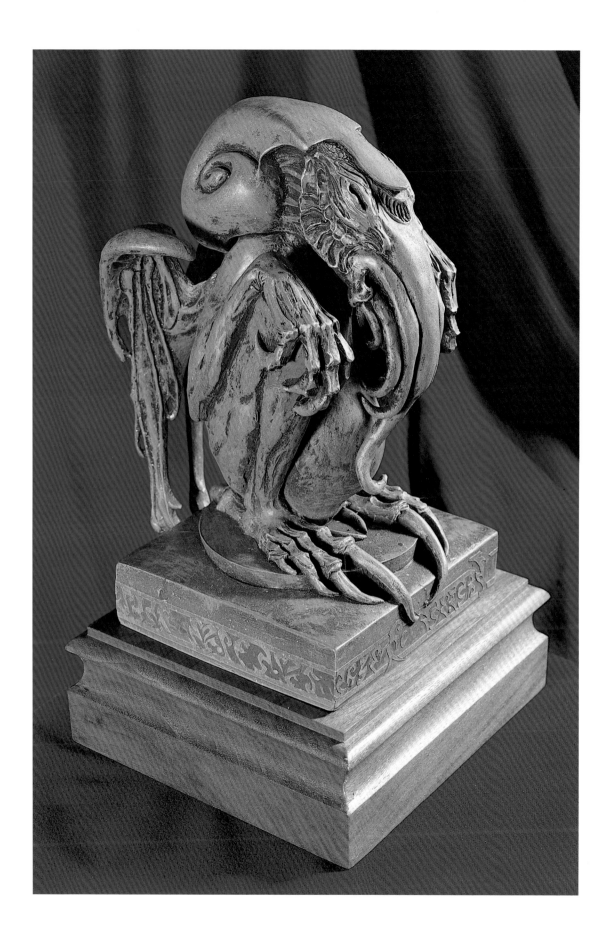

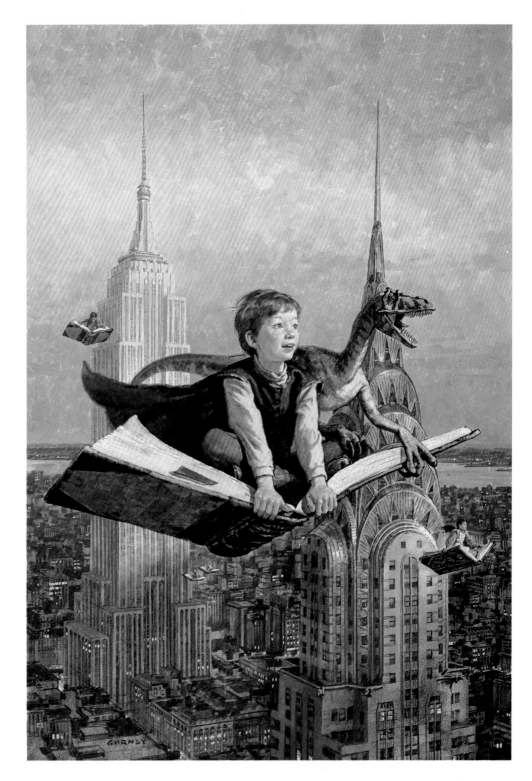

artist: **JAMES GURNEY**
art director: Jane Lahr
designer: Judy Turziano
client: Turner Publishing
title: Flight of Fancy
medium: Oil on board
size: 18"x26½"

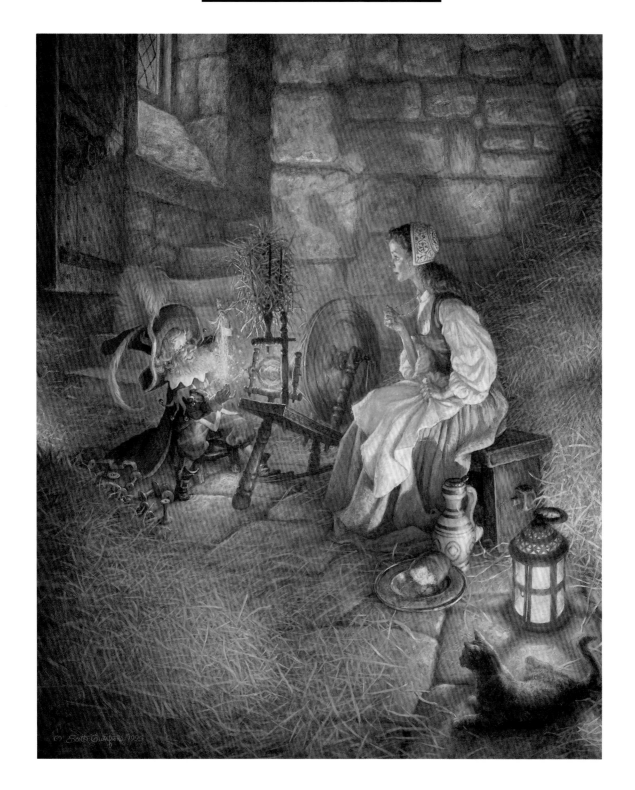

artist: **SCOTT GUSTAFSON**
art director: David Usher & Jennifer Oakes
designer: Scott Gustafson
client: The Greenwich Workshop
title: Rumplestilskin
medium: Oil
size: 26"x32"

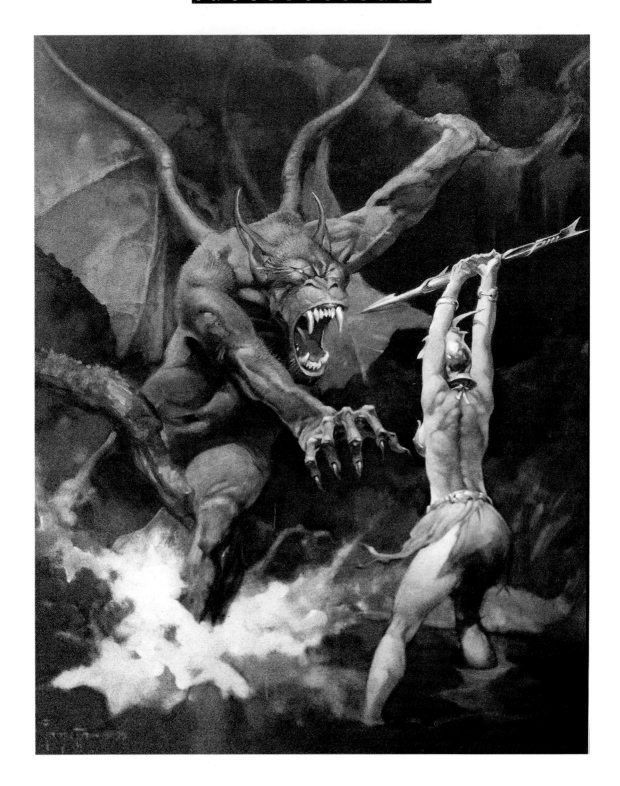

artist: **FRANK FRAZETTA**
art director: Maria Cabardo
designer: Maria Cabardo
client: Everway: Wizards of the Coast
title: The Spring Born
medium: Oil

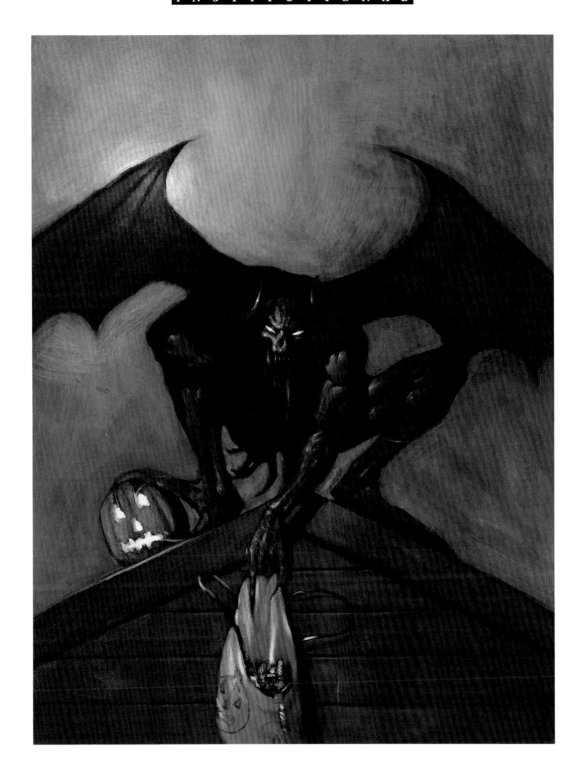

artists: **JAY HONG**
designer: Jay Hong
client: Self Promotion
title: Trick or Treat
medium: Acrylic
size: 10"x14"

1

2

1
artist: **DiTERLIZZI**
art director: Angela Defrancis
designer: DiTerlizzi
client: DiTerlizzi Illustration
title: Endless Journey
medium: Ink & watercolor
size: 20"x30"

2
artist: **JOHN BOLTON**
art director: Kim Francisco
designer: Kim Francisco
client: Wizards of the Coast
title: Vampire: The Eternal Struggle
medium: Mixed

3
artist: **WES BENSCOTER**
art director: Wes Benscoter
designer: Wes Benscoter
title: Lowlife
medium: Acrylic
size: 18"x24"

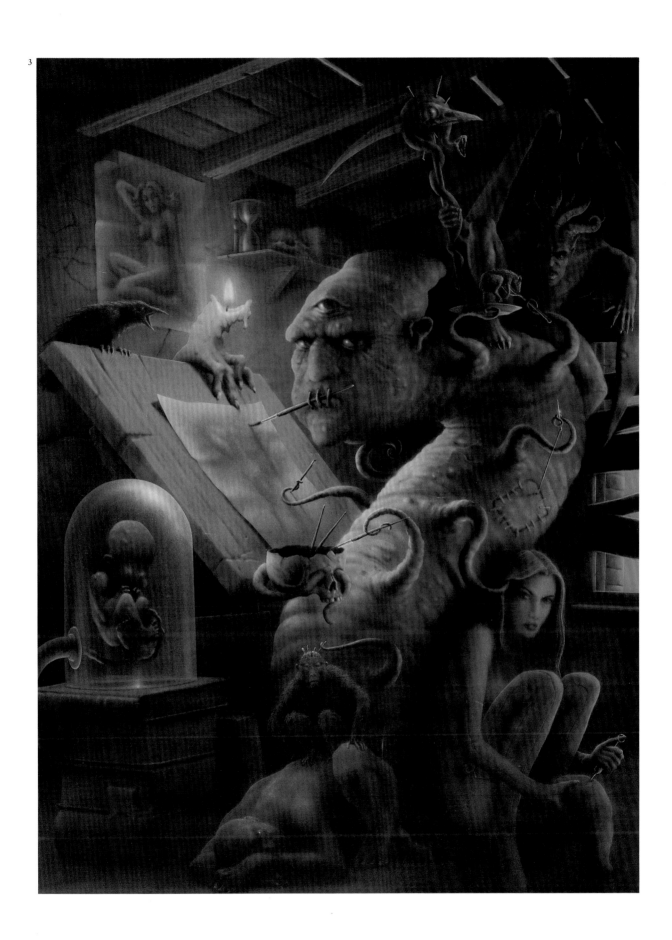

1

1

artist: **JAMES GURNEY**
art director: Scott Usher
client: The Greenwich Workshop
title: Twilight in Bonabba
medium: Oil on board
size: 11⅜"x18¼"

2

artist: **TERESE NIELSEN**
art director: Ted Adams
designer: John Uhrich & Tobias Queck
client: Wildstorm Productions
title: Savant
medium: Acrylic & gouache
size: 6¼"x11¼"

3

artist: **BRIAN FROUD**
art director: Maria Cabardo
designer: Maria Cabardo
client: Everway/Wizards of the Coast
medium: Mixed

2

3

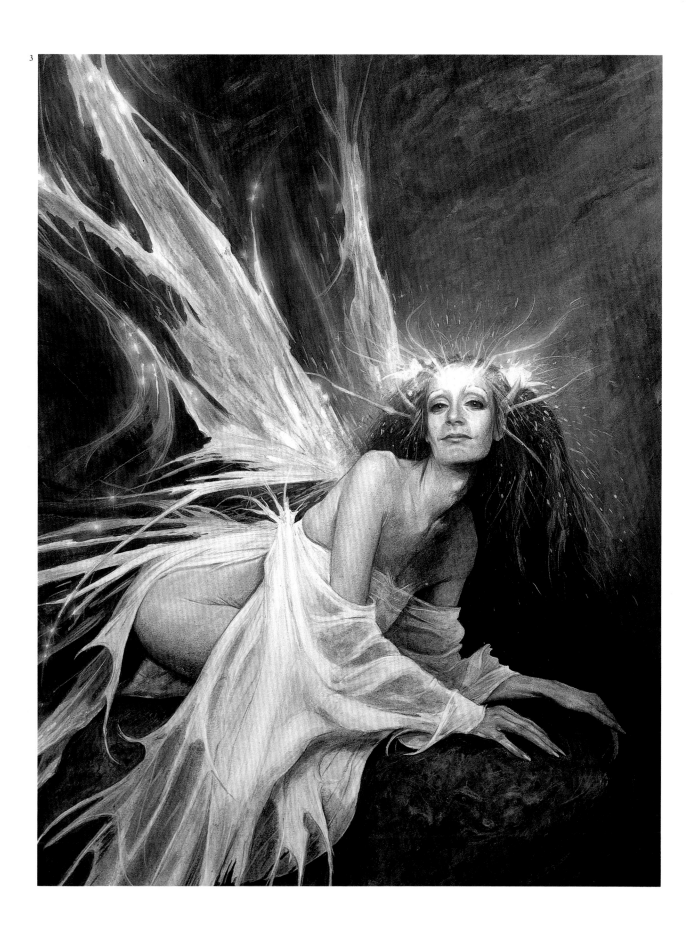

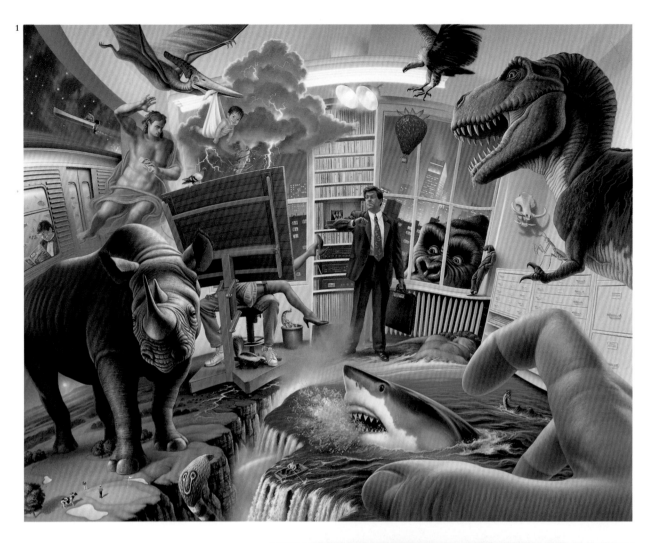

1
artist: **JERRY LOFARO**
art director: Jerry Lofaro
designer: Jerry Lofaro
client: Self promotion/American Showcase
title: Nothing Will Distract Me
 From My Next Assignment
medium: Acrylic
size: 16"x20"

2
artist: **JOE JUSKO**
art director: Brent Miller
client: FPG
title: John Carter of Mars
medium: Acrylic
size: 21"x23"

3
artist: **GARY RUDDELL**
art director: Jim Baen
designer: Gary Ruddell
client: Baen Publications
title: Dydeetown World
medium: Oil
size: 18"x24"

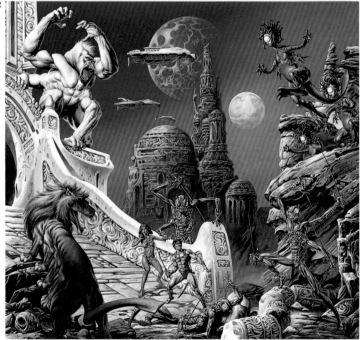

3

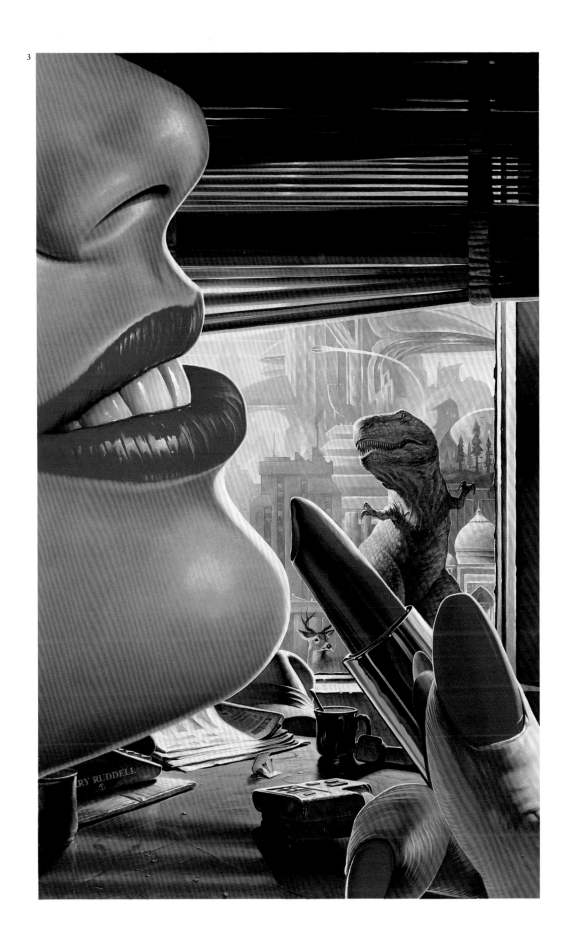

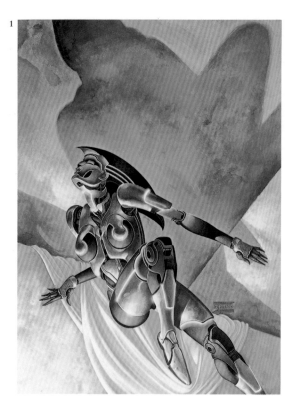

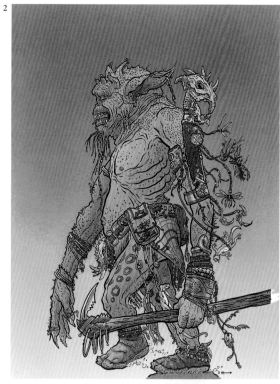

1

artist: **JOHN ZELEZNIK**
client: Zeleznik Illustration
title: Z1-AV79
medium: Acrylic
size: 15"x21"

2

artist: **GEOF DARROW**
art director: Maria Cabardo
designer: Maria Cabardo
client: Everway/Wizards of the Coast
title: Magic Hunger
medium: Ink & gouache

3

artist: **DAVID DeVRIES**
art director: Ben Plavin
client: Fleer Corporation
title: Red Skull
medium: Acrylic
size: 7½"x9½"

4

artist: **DAVID DeVRIES**
art director: Ben Plavin
client: Fleer Corporation
title: Namor
medium: Acrylic
size: 8"x11"

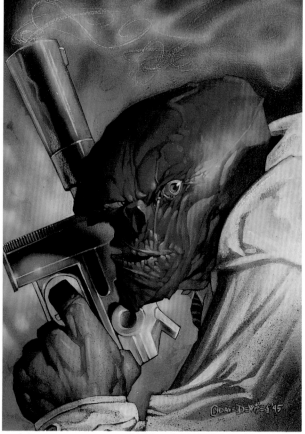

Red Skull copyright © & TM 1996 by Marvel Entertainment Group.

4

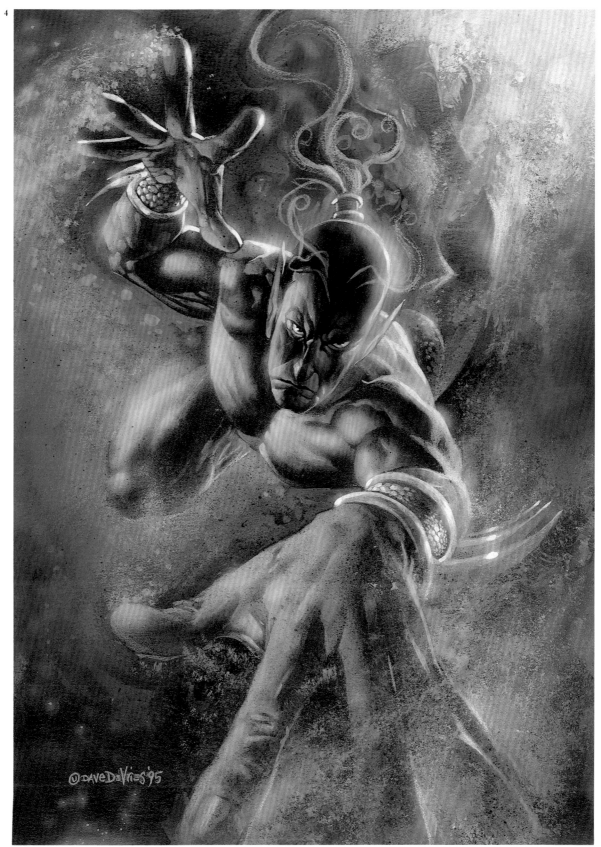

© DAVE DeVries '95

Namor copyright © & TM 1996 by Marvel Entertainment Group.

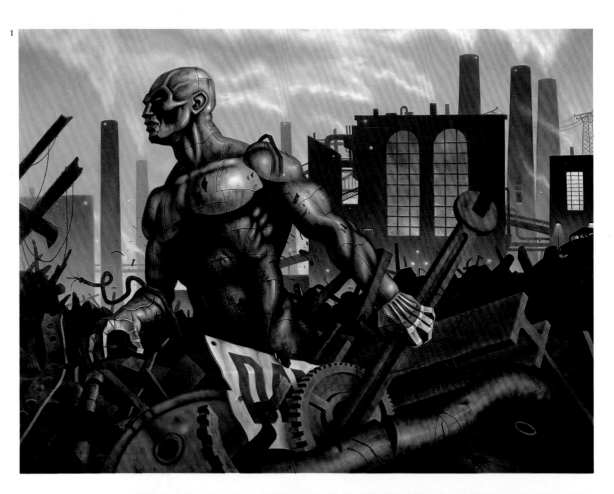

1
artist: **MARK COVELL**
art director: Mark Covell
medium: Oil
size: 25"x19"

2
artist: **JOHN MATSON**
art director: Chris McDonough
designer: John Matson
client: White Wolf, Inc.
title: Fetal Position
medium: Mixed
size: 5¼"x6¾"

3
artist: **MARC GABBANA**
designer: Marc Gabbana
client: Self promotion
title: It's Alive
medium: Gouache
size: 14"x18"

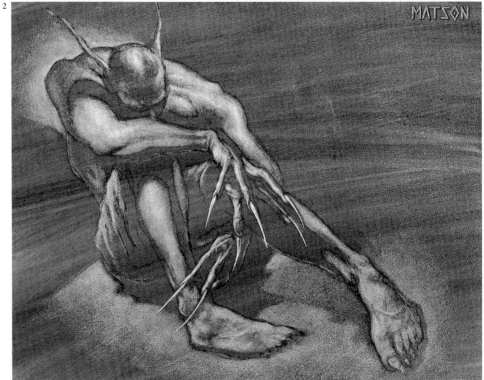

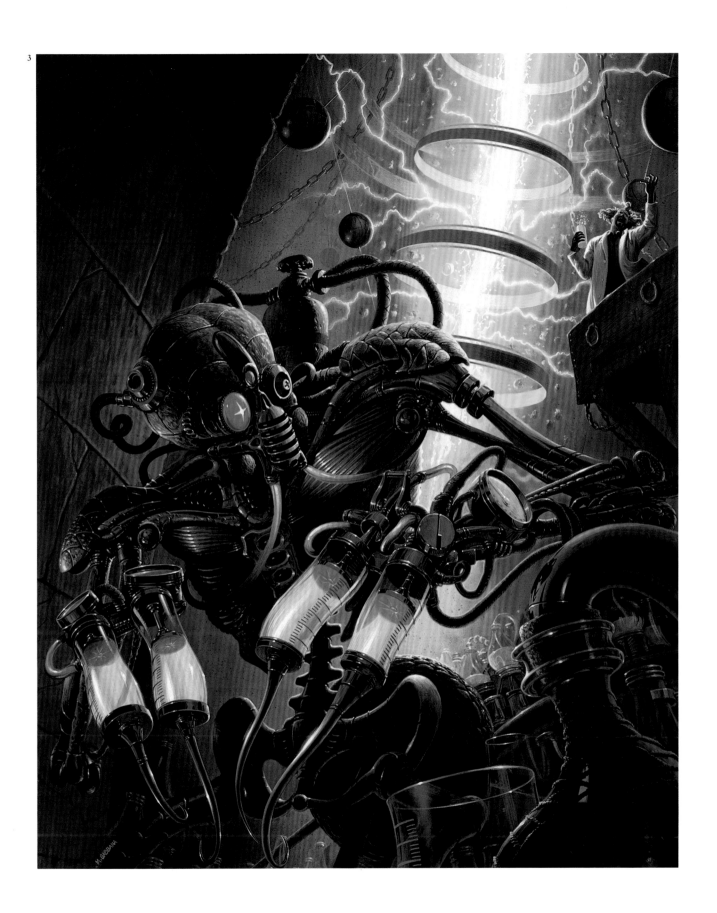

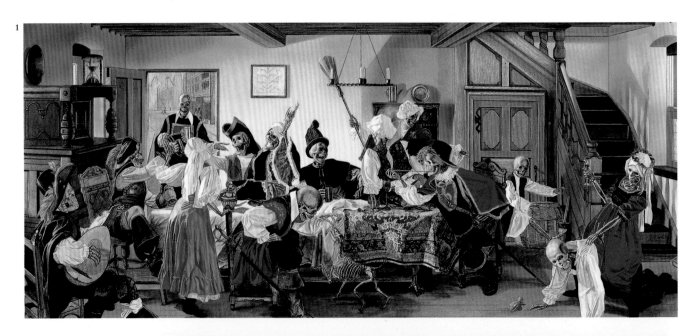

1
artist: **PATRICK WHELAN**
art director: Patrick Whelan
designer: Richard Burmood
client: Mastergraphics
title: Holiday
medium: Oil & acrylic
size: 37"x15"

2
artist: **STEVEN ASSAEL**
art director: Steven Assael
designer: Steven Assael
client: Steven Assael
title: Claire
medium: Oil on board
size: 16"x12"

3
artist: **RICK BERRY**
designer: Rick Berry
client: Last Unicorn Games
title: Virtual Orpheus
medium: Oil/digital

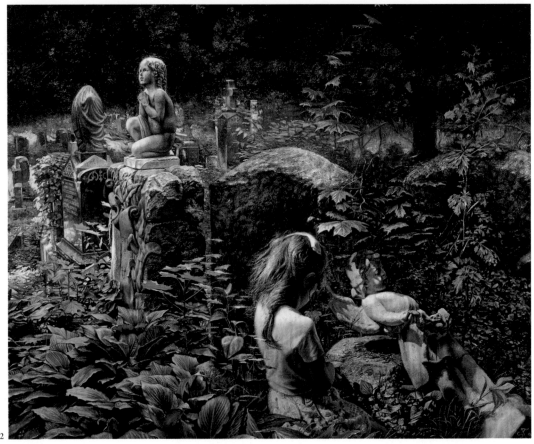

3

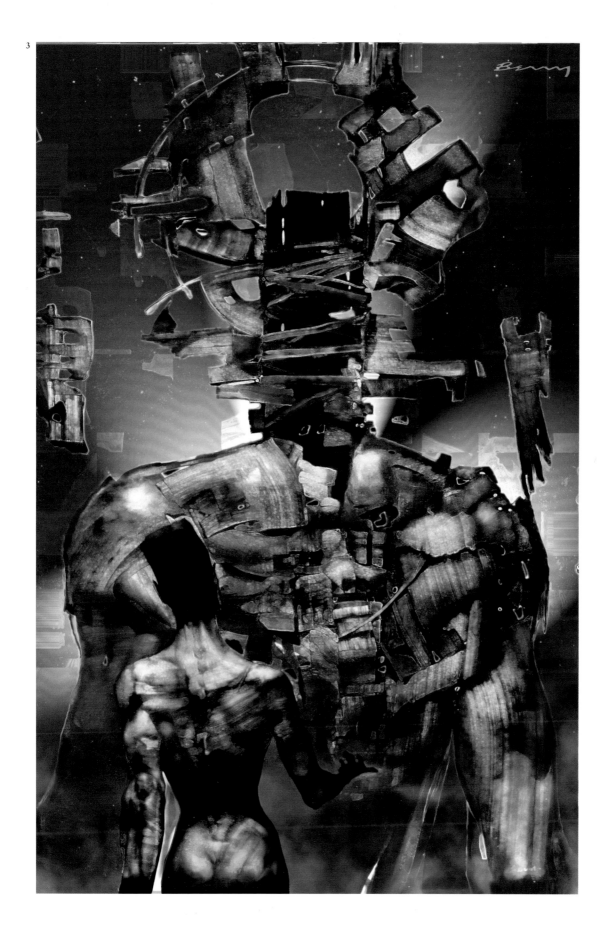

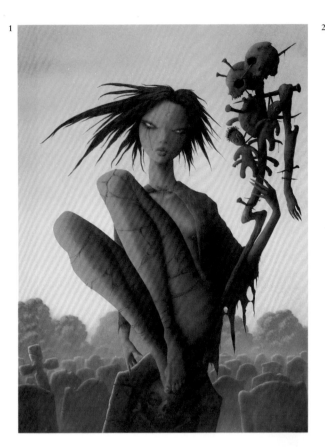

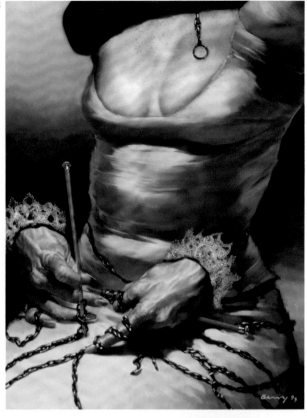

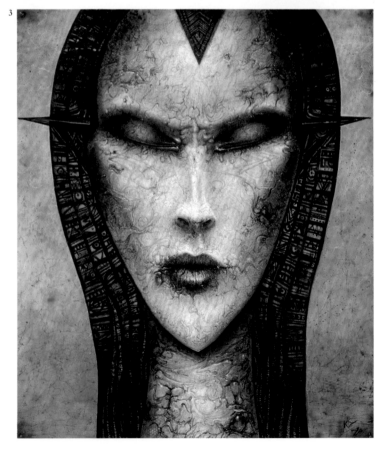

1
artist: **WES BENSCOTER**
art director: Wes Benscoter
designer: Wes Benscoter
client: Wes Benscoter
title: Standpoint
medium: Acrylic
size: 18"x24"

2
artist: **RICK BERRY**
designer: Rick Berry
title: Chainknit
medium: Oil/digital

3
artist: **K.D. MATHESON**
art director: Rochelle Phister
client: Dark's Art Parlour
title: Mona Verde
medium: Acrylic on paper
size: 36"x48"

4
artist: **JOE JUSKO**
client: Harris Comics
title: Vampirella
medium: Acrylic
size: 16"x26"

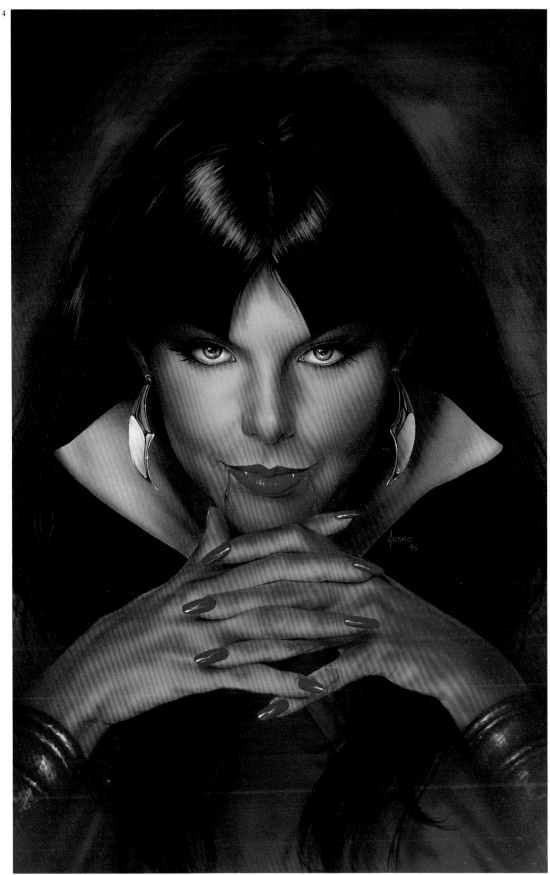

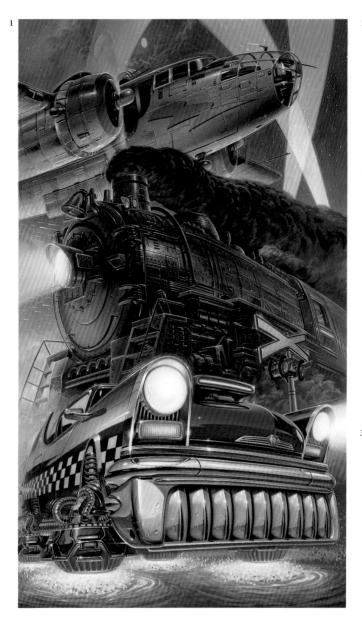

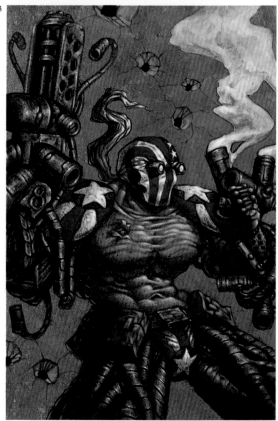

1

artist: **MARC GABBANA**
designer: Rochelle Phister
client: Self promotion
title: Going Places!
medium: Gouache
size: 14"x24"

2

artist: **DAVID DeVRIES**
art director: Ben Plavin
client: Fleer Corporation
title: Sabretoothe
medium: Acrylic
size: 8"x11"

3

artist: **SEAN COONS**
art director: David Mocarski
title: Super Patriot
medium: Arylic & bronze leaf
size: 12"x16"

4

artist: **DOUG CHIANG**
art director: Doug Chiang
title: Robot Wars
medium: Acrylic
size: 9½"x11"

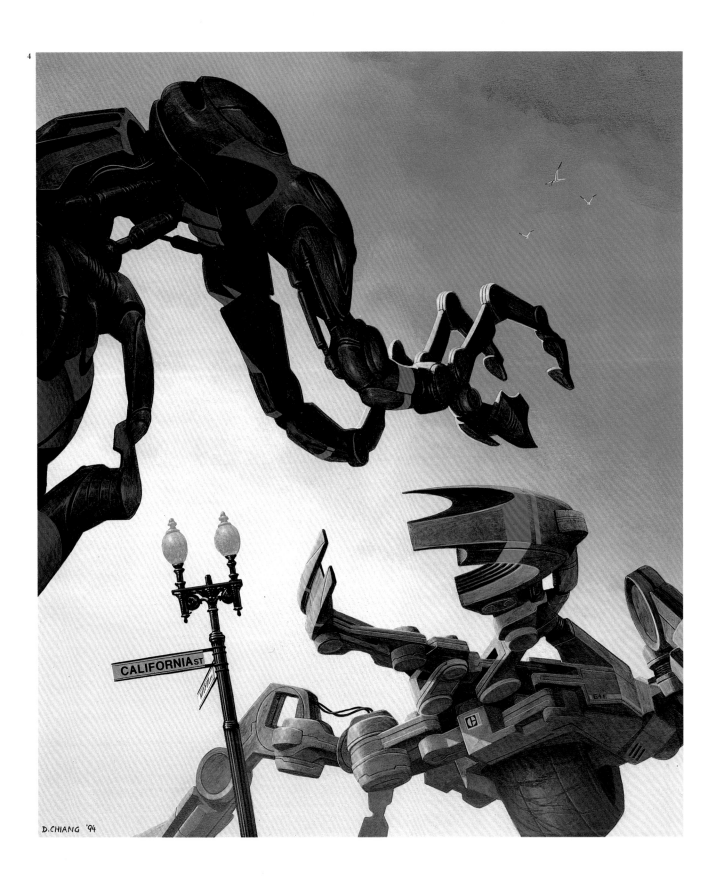

4

D.CHIANG '94

CALIFORNIA ST

1
artist: **JAEL**
designer: Claudia Goodridge
client: MBI (Danbury Mint)
title: Dream Fantasy
medium: Oil & acrylic
size: 30"x26"

2
artist: **WILLIAM STOUT**
client: Terra Nova Press
title: White Bear King Valemon
 (after T. Kittelsen)
medium: Ink & watercolor on board
size: 6⅜"x9¼"

3
artist: **SCOTT GUSTAFSON**
art director: David Usher
client: The Greenwich Workshop
title: Advice From a Caterpillar

4
artist: **CHUCK GILLIES**
art director: Josh Hanft
client: Elizabeth Stone Gallery
title: Little Red Riding Hood
medium: Acrylic
size: 10"x16"

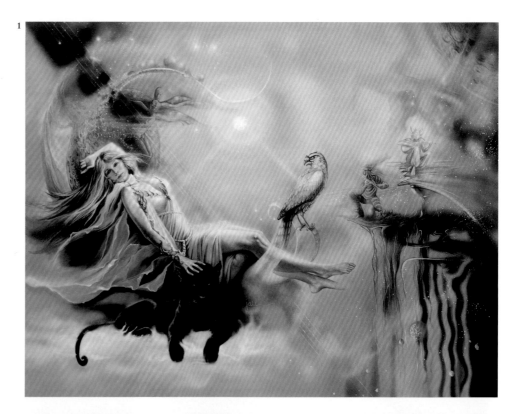

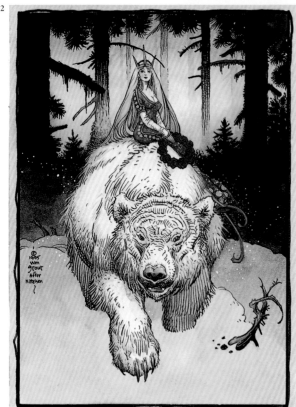

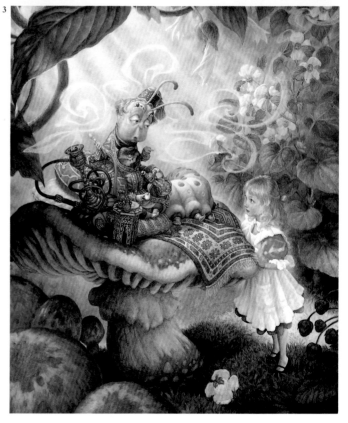

4

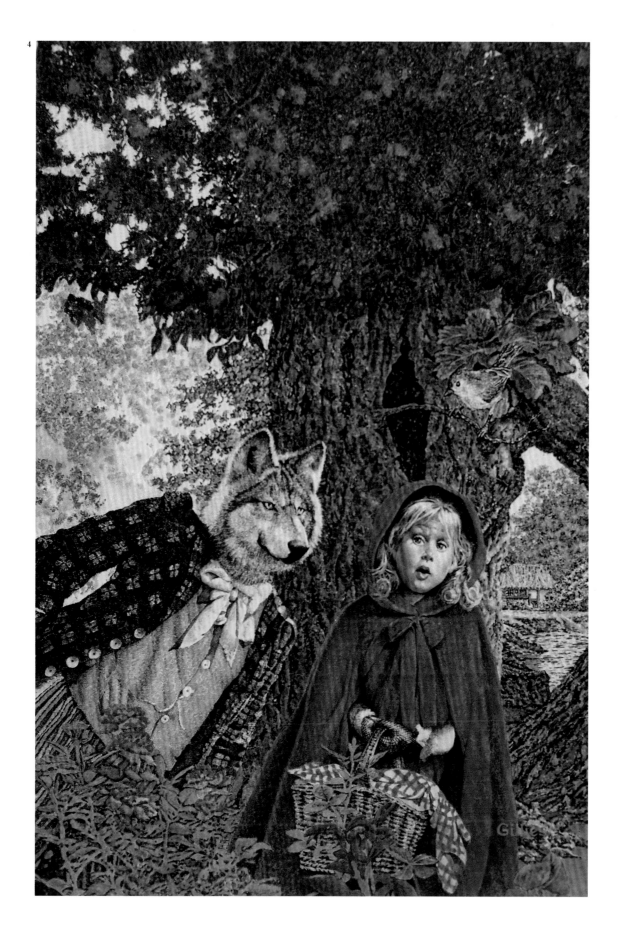

1

artist: **DOUG CHIANG**
art director: Doug Chiang
title: Robot Wars
medium: Acrylic
size: 7"x11"

2

artist: **JAY HONG**
client: Self promotion
title: Breaking Through
medium: Acrylic
size: 10"x15"

3

artist: **RICK BERRY**
client: Self promotion
title: Oracle
medium: Digital

4

artist: **MORGAN WEISTLING**
art director: Morgan Weistling
client: The Hamilton Collection
title: Star Wars
medium: Oil
size: 15"x15"

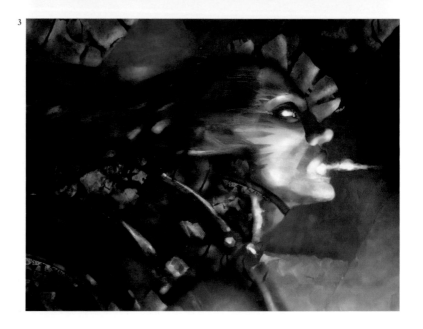

4

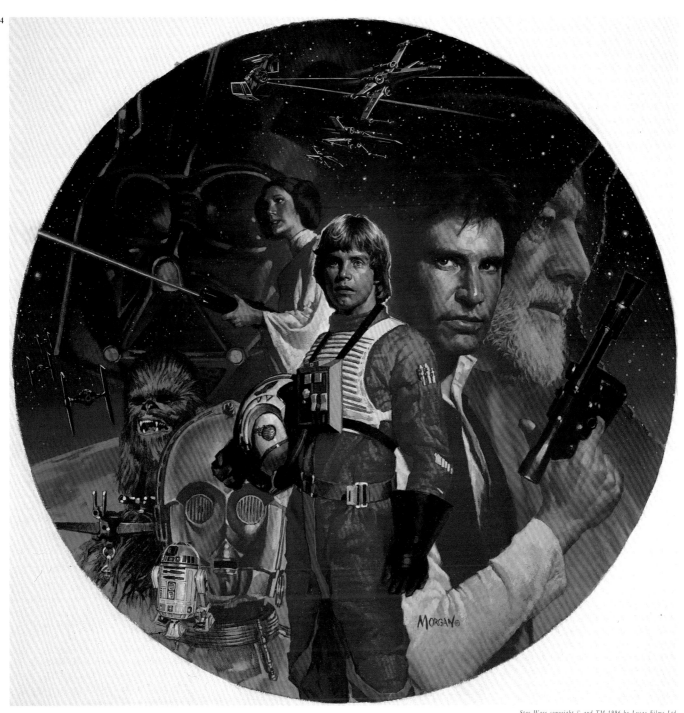

Star Wars copyright © and TM 1996 by Lucas Films Ltd.

1
artist: **DON MAITZ**
art director: Keith Parkinson
designer: Mike Ploog
client: FPG
title: Cleric
medium: Oil on masonite
size: 11"x14"

2
artist: **JEFF PITTARELLI**
client: Self promotion
title: Julie's Nightmare
medium: Acrylic on canvas
size: 60"x48"

3
artist: **JOHN BOLTON**
art director: Maria Cabardo
designer: Maria Cabardo
client: Everway/Wizards of the Coast
medium: Mixed

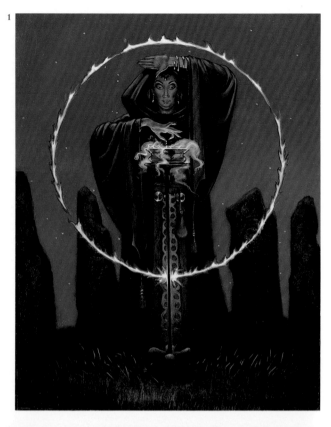

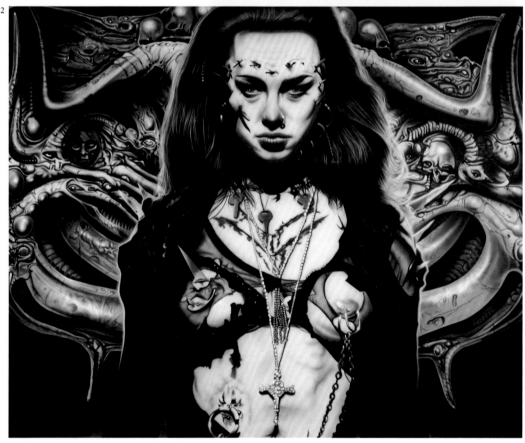

3

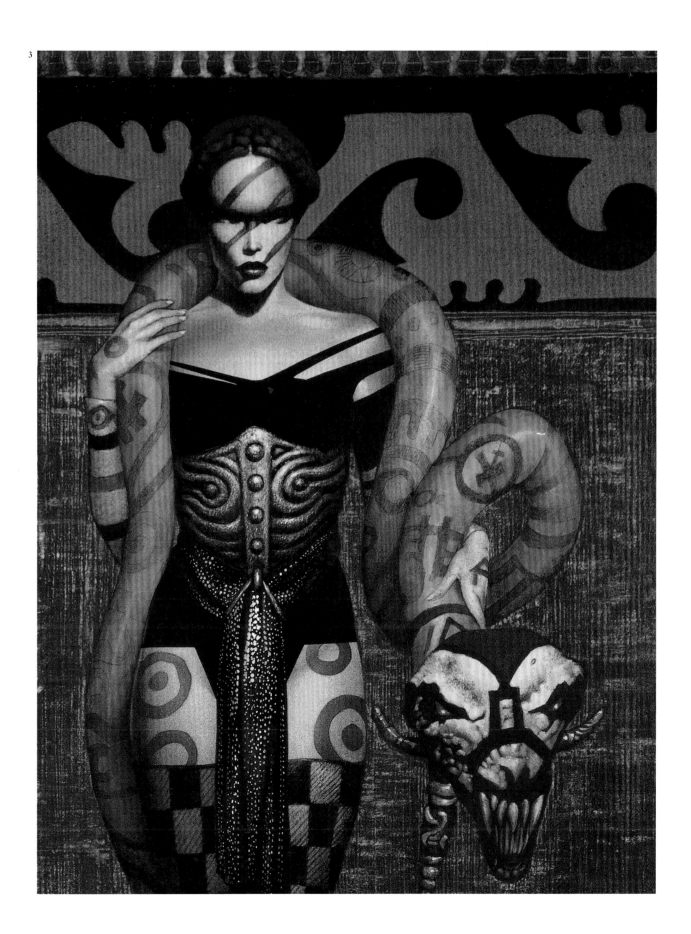

1
artist: **TIM O'BRIEN**
designer: Tim O'Brien
client: Self promotion
medium: Oil
size: 22"x14"

2
artist: **PATRICK ARRASMITH**
art director: Adina Sales
title: Self Portrait
medium: Acrylic & scratchboard
size: 11"x17"

3
artist: **ROBH RUPPEL**
client: FPG
title: October I
medium: Oil
size: 8"x10"

4
artist: **MATT MANLEY**
art director: Richard Lebeson
designer: Matt Manley
client: RSVP 21
title: Wandering Between Two Worlds...
medium: Oil
size: 12"x17"

1
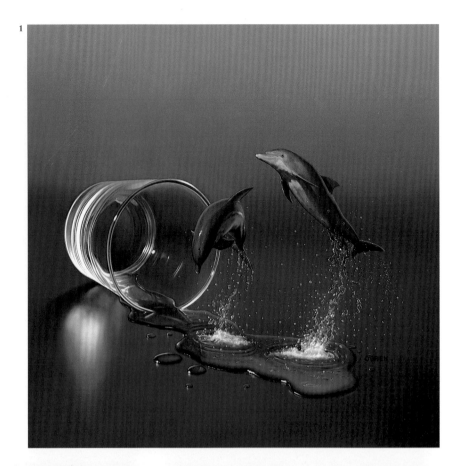

2
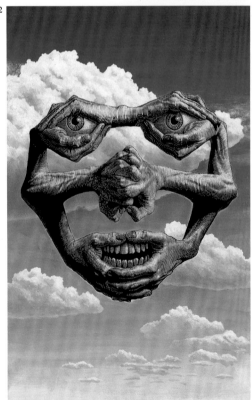

3
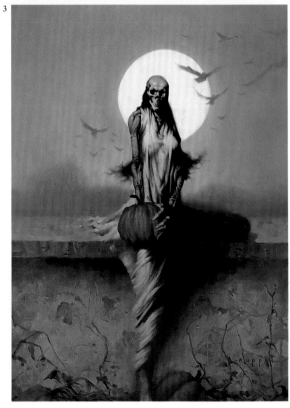

4

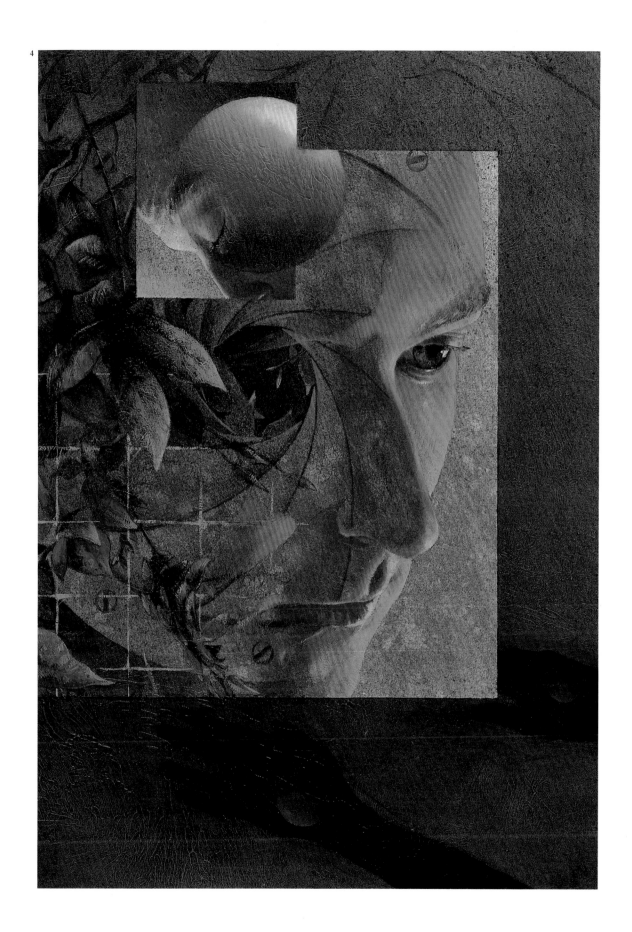

1
artist: **ERIC BOWMAN**
art director: Eric Bowman
designer: Eric Bowman
title: Big Top
medium: Acrylic
size: 9"x16"

2
artist: **RICK BERRY**
with **Darrel Anderson**
client: Last Unicorn Games
title: Zophiel
medium: Digital

3
artist: **RICK BERRY**
art director: Maria Cabardo
designer: Maria Cabardo
client: Everway/Wizards of the Coast
title: The Witch
medium: Oil

4
artist: **ROB BLISS**
art director: Maria Cabardo
designer: Maria Cabardo
client: Ars Magica/Wizards of the Coast
medium: Mixed

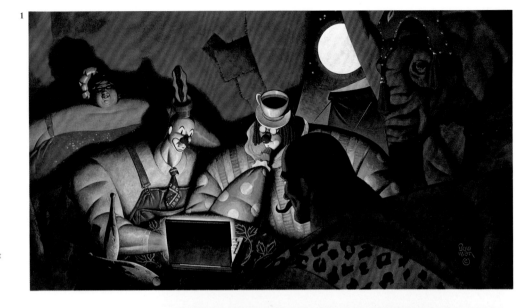

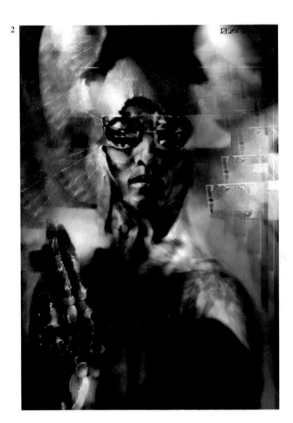

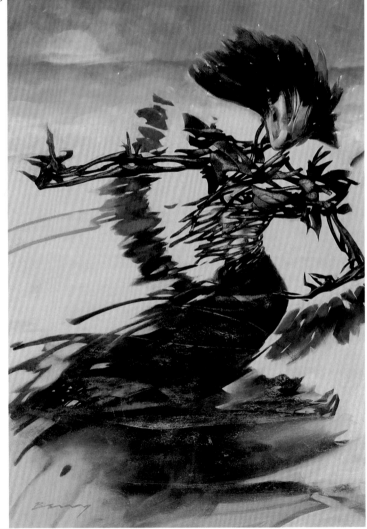

4

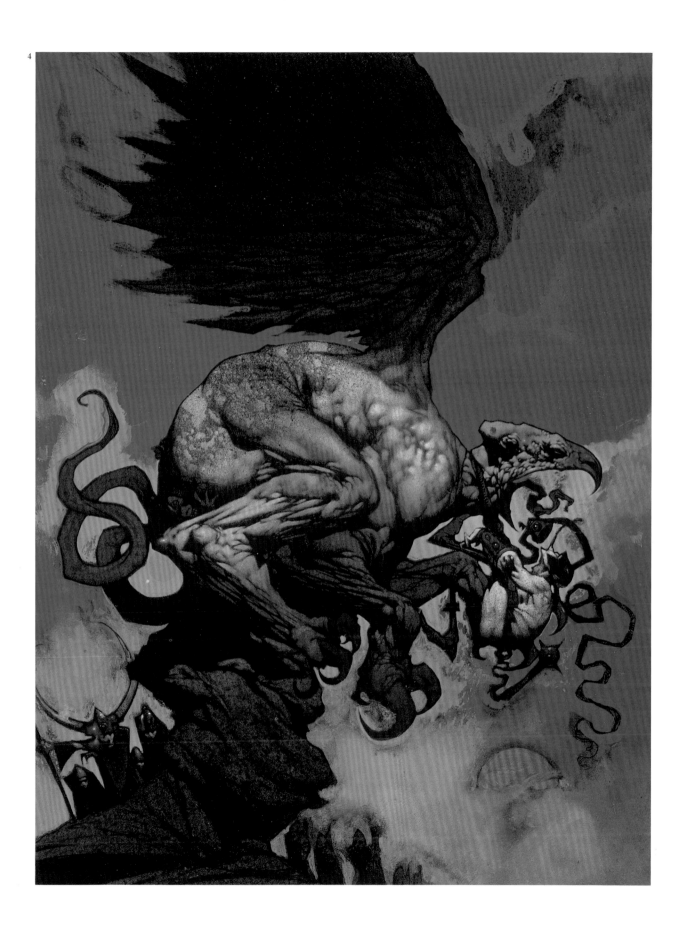

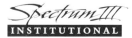

1
artist: **DAVID DeVRIES**
art director: Tom Brevoort
client: Marvel Entertainment
title: Wolverine vs Sauron
medium: Acrylic
size: 20"x15"

2
artist: **WILLIAM STOUT**
client: Terra Nova Press
title: All Hallow's Eve
medium: Ink & watercolor
size: 6⅜"x9"

3
artist: **SIMON BISLEY**
art director: Maria Cabardo
designer: Maria Cabardo
client: Wizards of the Coast
medium: Oil

4
artist: **DAVID DeVRIES**
art director: Ben Plavin
client: Fleer Corporation
title: Rogue
medium: Acrylic
size: 8"x11"

1

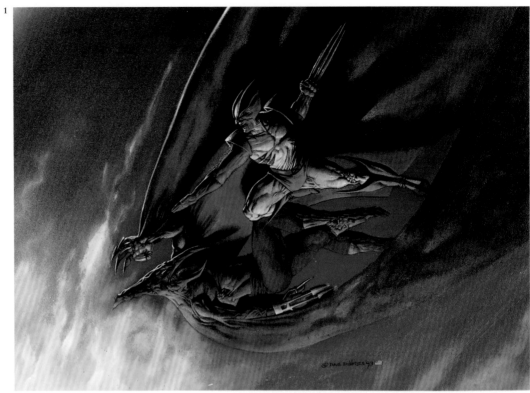

Wolverine & Sauron copyright © & TM 1996 by Marvel Entertainment Group.

2

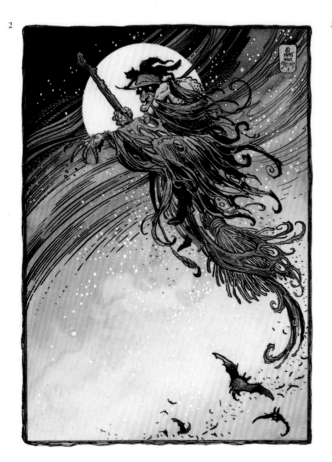

3

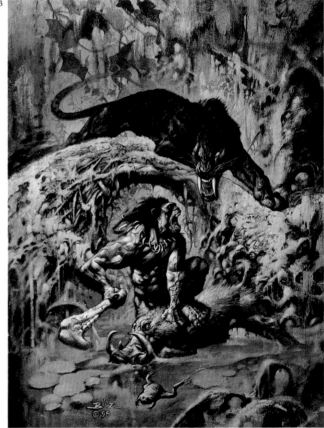

4

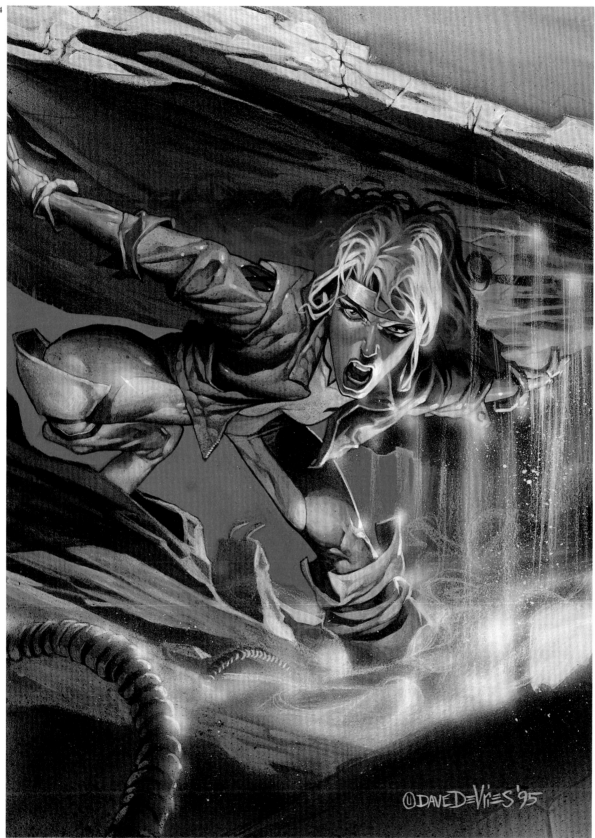

Spectrum III
INSTITUTIONAL

1
artist: **TODD LOCKWOOD**
art director: Todd Lockwood
client: Self promotion
title: Hell Friezes 1: Cerberus
medium: Pencil
size: 10½"x14"

2
artist: **LAUREL BLECHMAN**
client: Marvel Entertainment
title: Ghost Rider
medium: Acrylic

3
artist: **JAY HONG**
designer: Jay Hong
client: Self promotion
title: Alien Warrior
medium: Acrylic
size: 14"x20"

4
artist: **K.D. MATHESON**
art director: Rachelle Phister
client: Dark's Art Parlour
title: The Lord of the Flies
medium: Acrylic on paper
size: 50"x69"

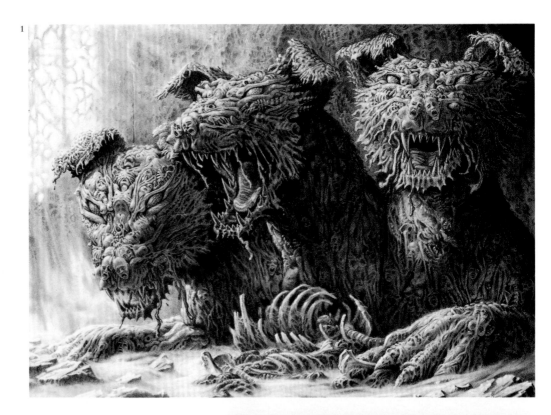

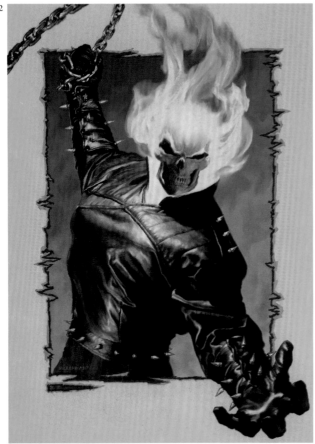

Ghost Rider copyright © & TM 1996 by Marvel Entertainment Group.

4

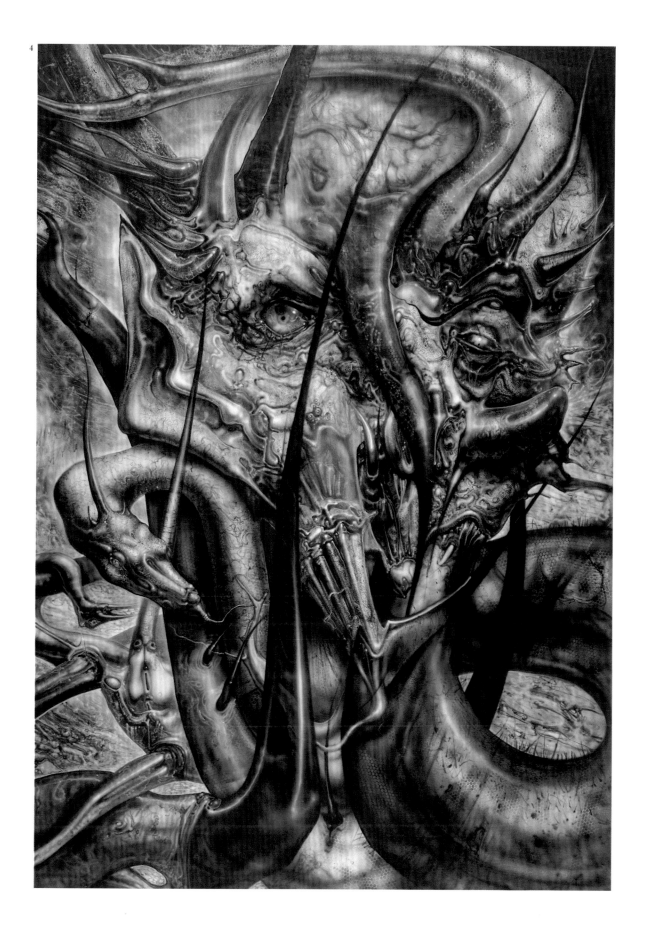

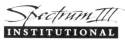

INSTITUTIONAL

1
artist: **JOSEPH VARGO**
art director: Joseph Vargo
client: Monolith Graphics
title: Gargoyles
medium: Acrylic
size: 18"x24"

2
artist: **DAVID A. CHERRY**
art director: Felicia Brown
client: The Hamilton Collection
title: The Lovers
medium: Acrylic
size: 30"x40"

3
artist: **RICK BERRY**
with **Michael Wm. Kaluta**
client: Last Unicorn Games
title: Heresy
medium: Oil & digital

4
artist: **WILLIAM STOUT**
client: Terra Nova Press
title: Sea Fantasy
medium: Ink & watercolor on board

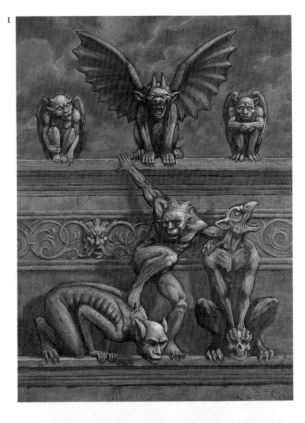

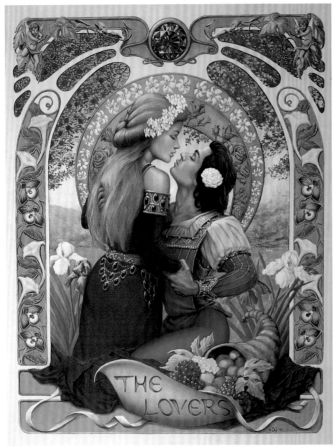

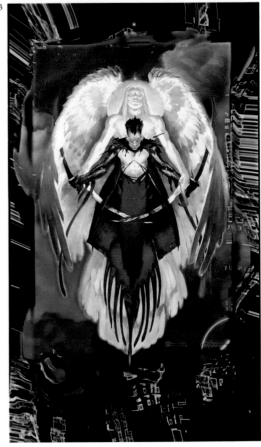

4

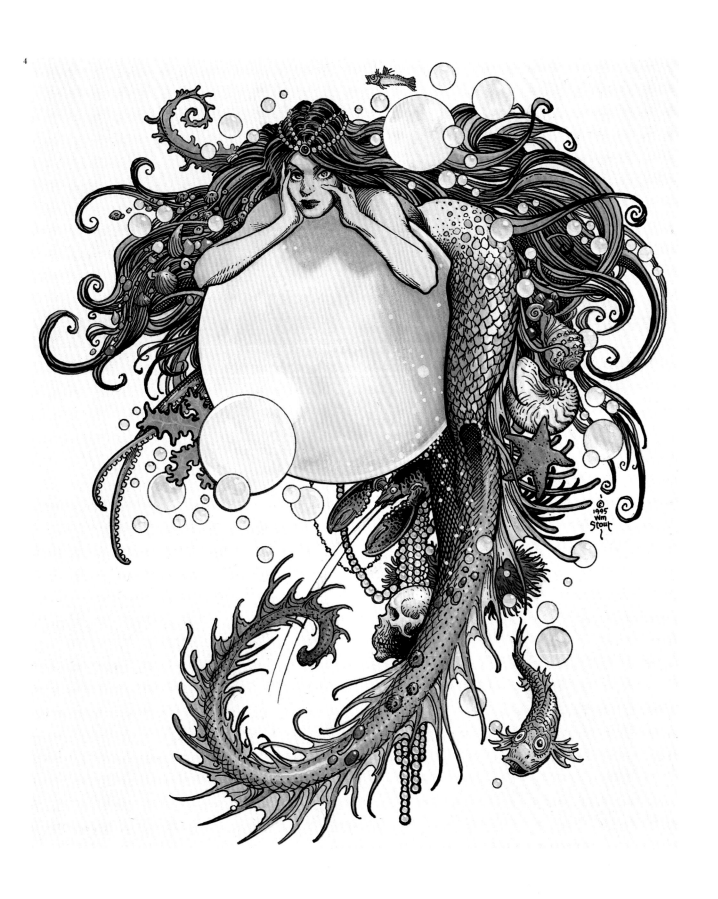

1
artist: **DARREL ANDERSON**
client: Braid Media Arts
title: Clockwork Ballet
medium: Digital

2
artist: **MARK COVELL**
art director: Mark Covell
medium: Oil
size: 18"x13"

3
artist: **IAN MILLER**
art director: Maria Cabardo
client: Wizards of the Coast
medium: Mixed

4
artist: **RICK BERRY**
art director: Maria Cabardo
client: Wizards of the Coast
medium: Oil

1

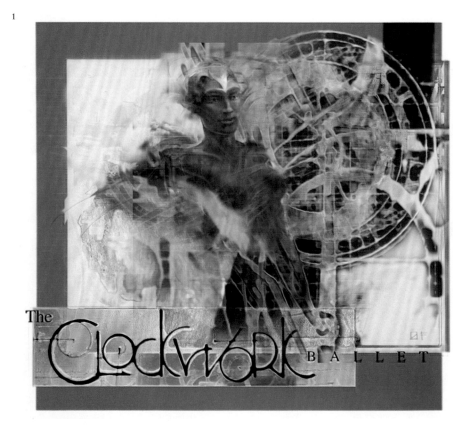

2

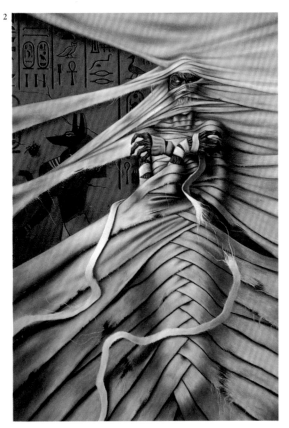

3

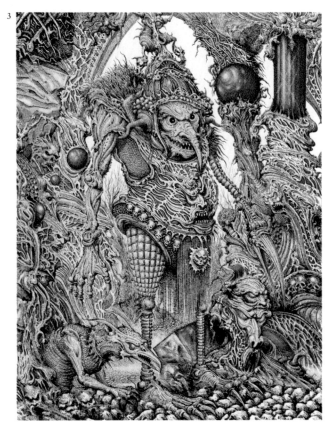

4

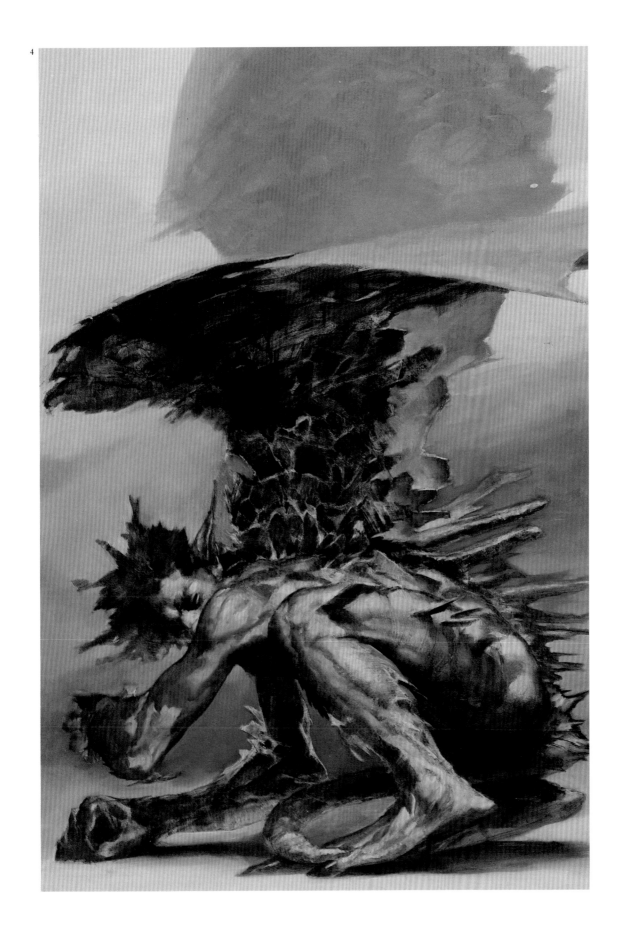

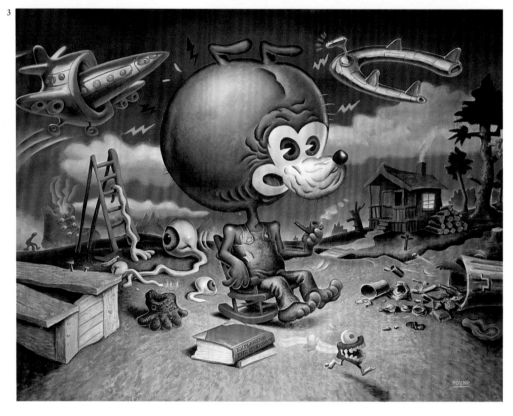

1
artist: **ROB BLISS**
art director: Maria Cabardo
designer: Maria Cabardo
client: Wizards of the Coast
title: Untitled
medium: Mixed

2
artist: **WILLIAM STOUT**
client: Terra Nova Press
title: Dragon's Slumber
medium: Ink & watercolor
on board
size: 6⅛"x9⅛"

3
artist: **JOHN POUND**
designer: John Pound
title: The Temptation
of St. Mickey
medium: Acrylic
size: 24"x30"

4
artist: **ROB BLISS**
art director: Maria Cabardo
designer: Maria Cabardo
client: Wizards of the Coast
medium: Mixed

4

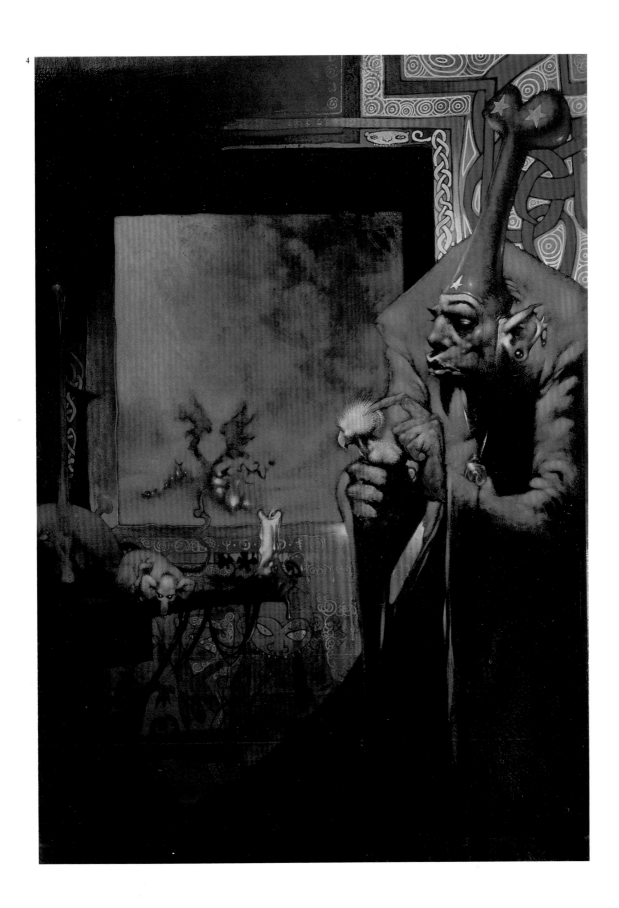

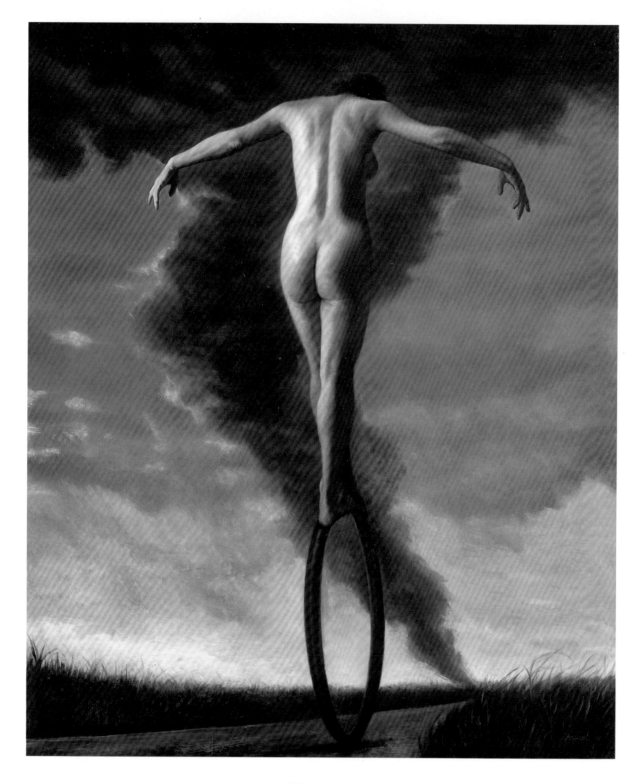

artist: **STEVEN ASSAEL**
art director: Steven Assael
designer: Steven Assael
client: Steven Assael
title: Twister
medium: Oil on board
size: 40"x60"

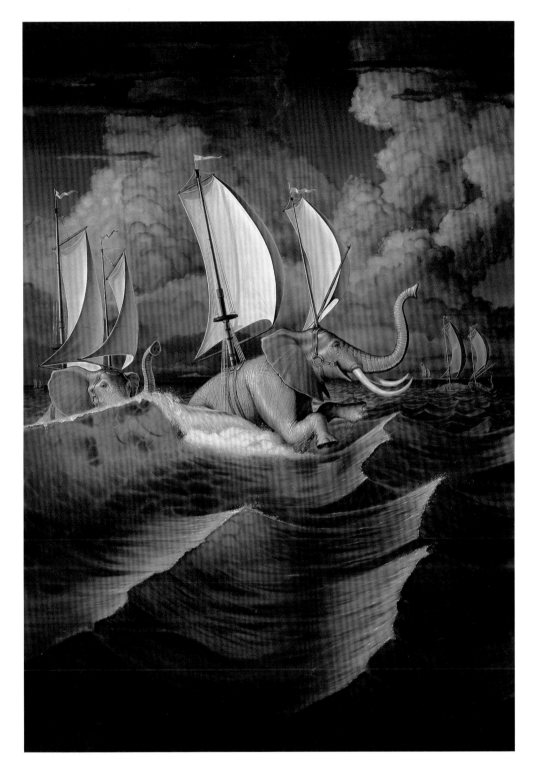

artist: **TIM O'BRIEN**
designer: Tim O'Brien
medium: Oil
size: 16"x26"

artist: **WALTER VELEZ**
art director: Walter Velez
designer: Walter Velez
title: Dragontails
medium: Acrylic
size: 18"x30"

artist: **JON FOSTER**
designer: Jon Foster
title: Alignment
medium: Mixed
size: 10"x14"

1
artist: **CARL LUNDGREN**
art director: Michele Lundgren
title: No Blood...So Far
medium: Oil on board
size: 60"x34"

2
artist: **MICHAEL WHELAN**
title: Crux Humanus
medium: Digital
size: 5"x5"

3
artist: **JOHN RUSH**
client: Eleanor Ettinger Gallery
title: Study of a Winged Figure
medium: Oil on canvas
size: 16"x24"

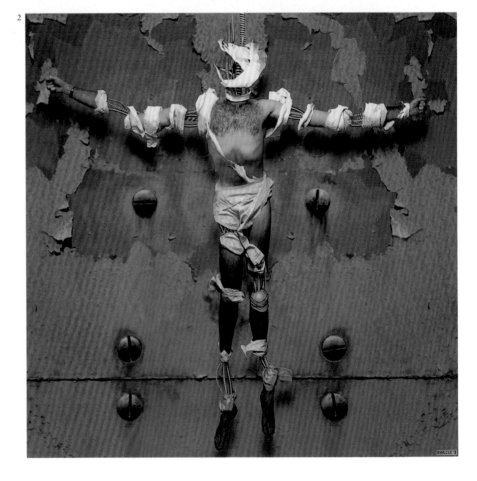

3

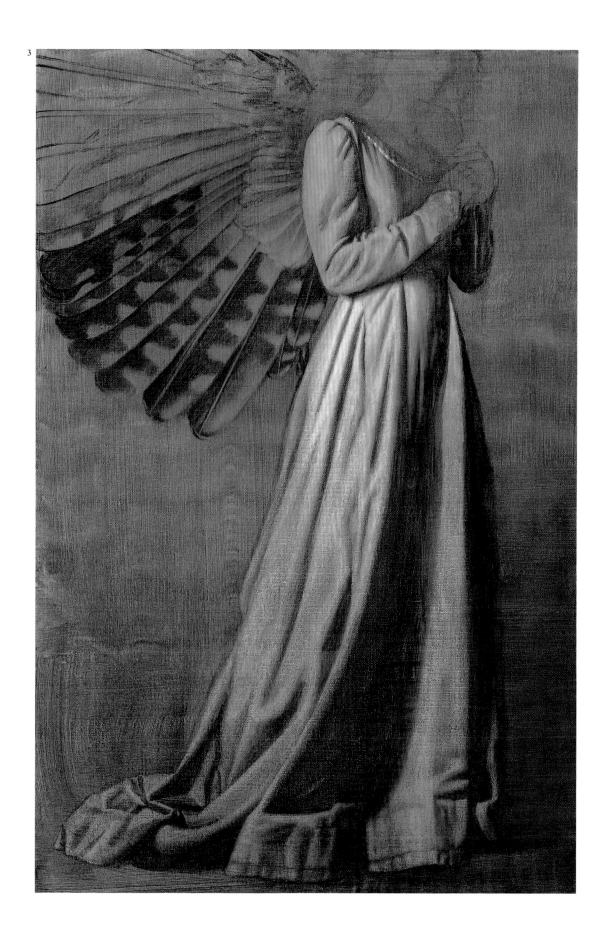

1
artist: **STEVE FERRIS**
title: Queen of the Nile
medium: Oil
size: 30"x30"

2
artist: **RICHARD HESCOX**
art director: Richard Hescox
designer: Richard Hescox
title: The Dreaming Sea
medium: Oil
size: 27"x23"

3
artist: **BARCLAY SHAW**
client: Barclay Shaw
title: Vesperal Clouds
medium: Oil
size: 32"x48"

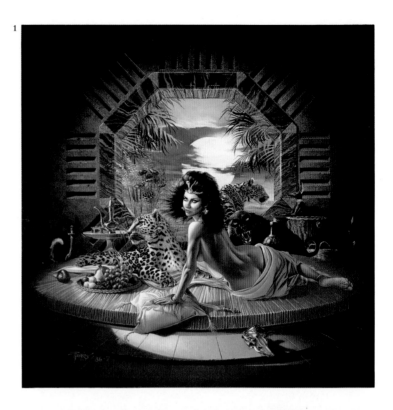

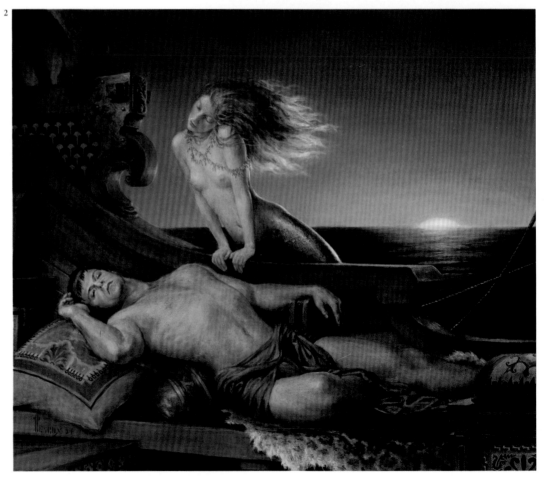

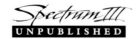

3

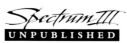

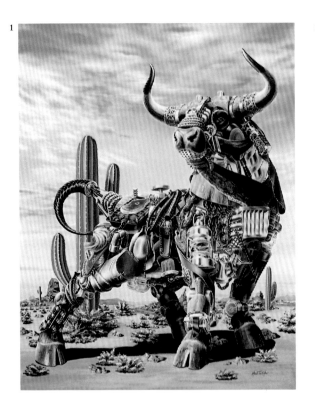

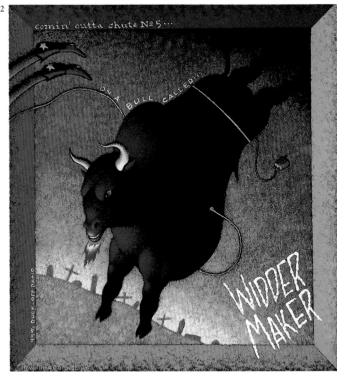

1

artist: **HEIDI TAILLEFER**
title: Harbinger's Tail
medium: Acrylic
size: 30"x40"

2

artist: **RAY-MEL CORNELIUS**
client: Dallas Society of Illustrators
title: Widow Maker
medium: Acrylic
size: 11"x12"

3

artist: **JAY JOHNSON**
client: Jay Johnson Illustration
title: The Hit
medium: Digital
size: 9"x10"

4

artist: **BILL NELSON**
art director: Bill Nelson
designer: Bill Nelson
client: The Creative Company
title: Sprouter
medium: Mixed
size: 7"x11"

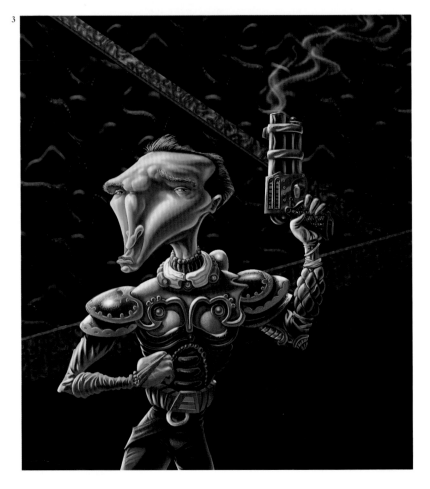

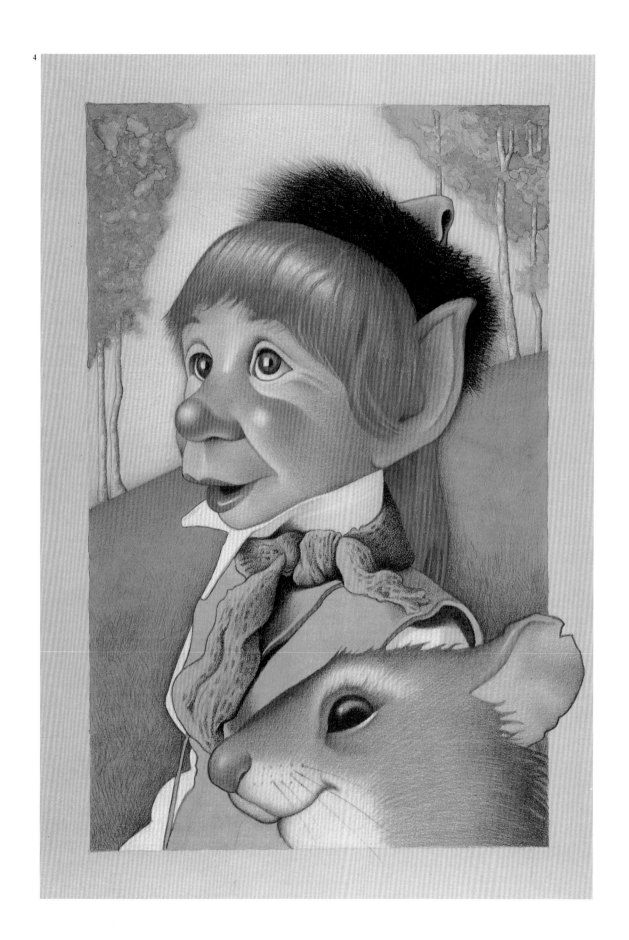

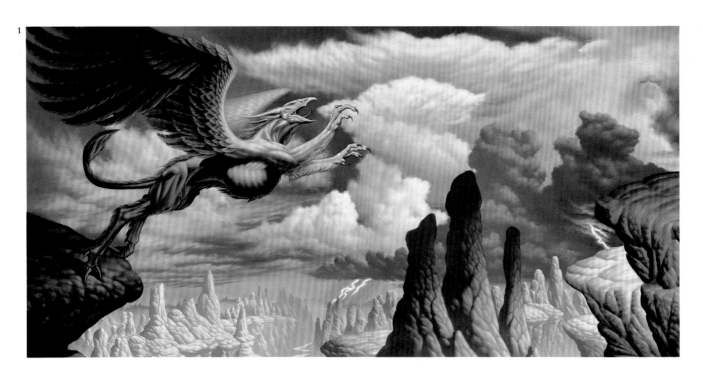

1
artist: **DAVID MARTIN**
title: Heart of Thunder
medium: Oil
size: 60"x36"

2
artist: **BILL NELSON**
art director: Bill Nelson
designer: Bill Nelson
client: The Creative Company
title: Stumpy
medium: Mixed
size: 7"x11"

3
artist: **EZRA TUCKER**
client: Ezra Tucker
title: American Storm
medium: Oil
size: 34"x24"

4
artist: **EZRA TUCKER**
client: Ezra Tucker
title: Midday Monarch
medium: Oil
size: 28"x18"

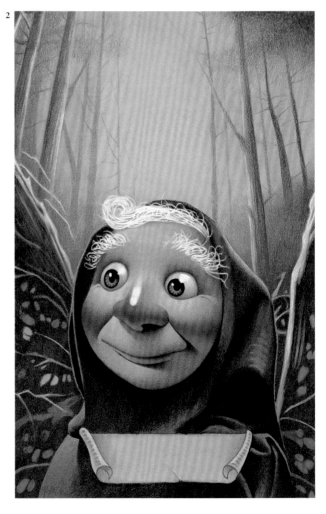

3

4

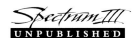

1
artist: **STEVE CRISP**
title: Ogen's Quest
medium: Gouache & acrylic
size: 18"x24"

2
artist: **JON FOSTER**
art director: Jon Foster
title: Ghost Dance
medium: Oil
size: 40"x26"

3
artist: **MIKE MIGNOLA**
art director: Scott Dunbier
designer: Mike Mignola
client: Wildstorm Productions
title: Hellboy
medium: Ink & watercolor
size: 16"x22"

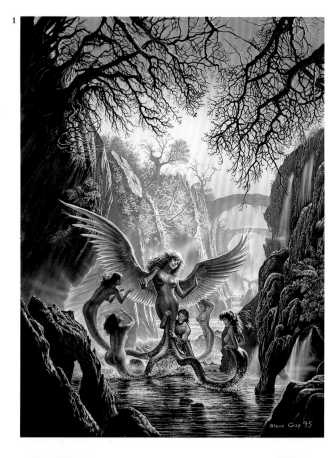

3

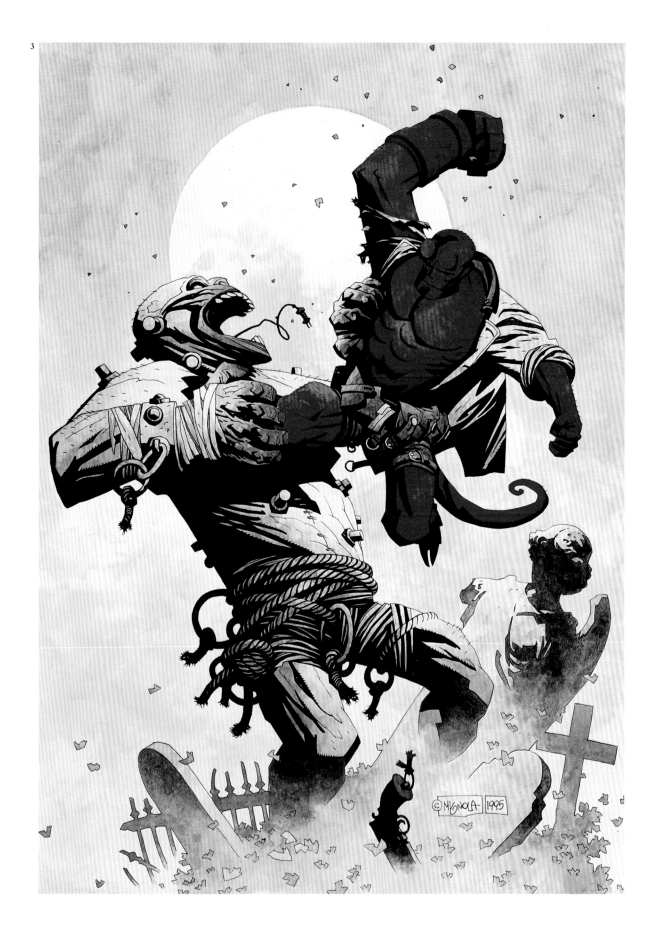

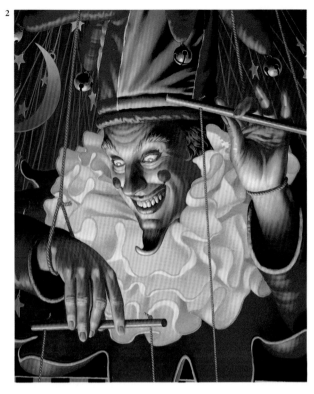

1
artist: **CARLOS BUTTS**
title: Abrasion/Cavity

2
artist: **WILL WILSON**
client: The John Pence Gallery
title: Pulling Strings
medium: Oil
size: 16"x20"

3
artist: **FRED FIELDS**
art director: Fred Fields
designer: Fred Fields
client: Self promotion
title: Sweet Necktar
medium: Oil
size: 11"x13½"

4
artist: **ARMAND BALTAZAR**
art director: Jeff Fey
title: Fairy Tales Taught Us
About a World That Might Be
medium: Oil
size: 17"x22"

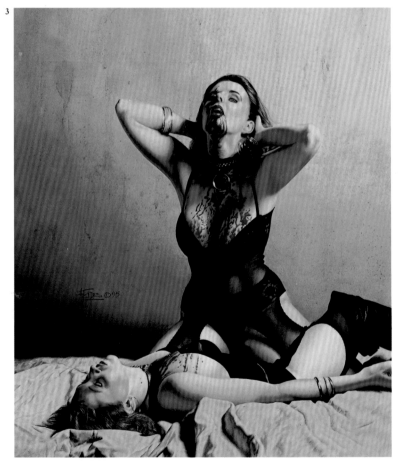

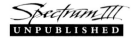

4

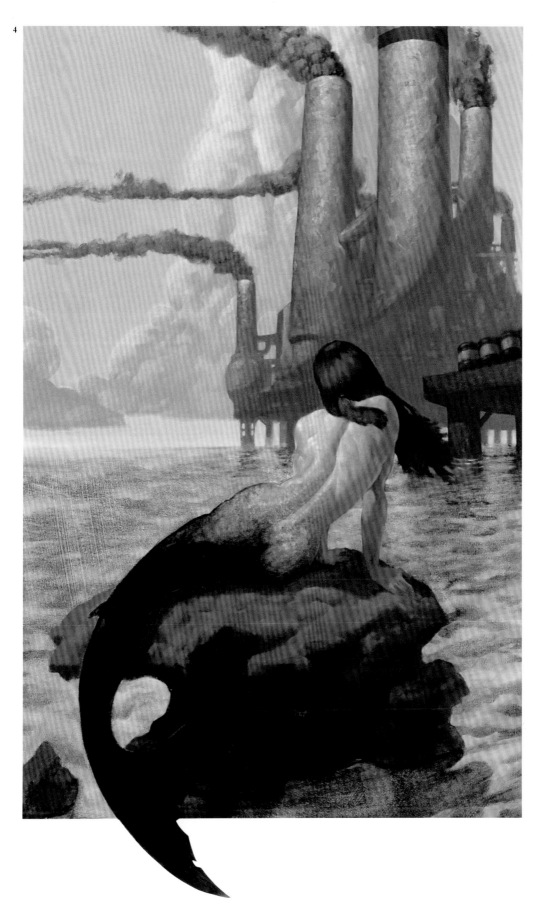

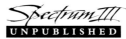

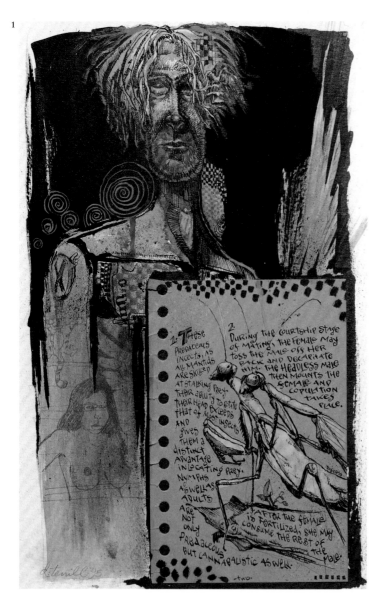

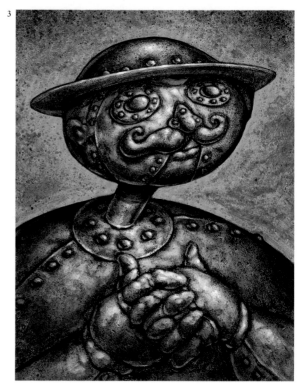

1
artist: **DAVE TERRILL**
art director: Dave Terrill
title: Mantis
medium: Mixed
size: 11"x14"

2
artist: **LARS GRANT-WEST**
art director: Lars Grant-West
title: An Unusual Friendship
medium: Oil on canvas
size: 22"x32"

3
artist: **SEAN COONS**
title: Tic Toc
medium: Acrylic
size: 8"x11"

4
artist: **MICHAEL ASTRACHAN**
medium: Oil
size: 16"x22"

4

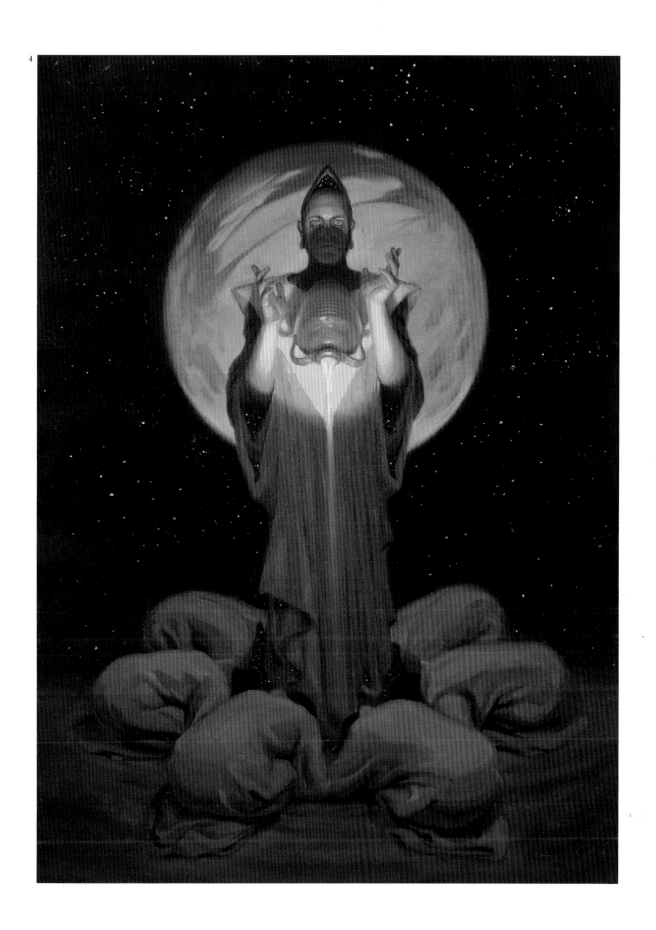

ARTIST INDEX

Paul Alexander, 33, 38
37 Pine Mtn. Rd.
W. Redding, CT 06896
203-544-9293

Darrel Anderson, 39, 49, 120
1420 Territory Trail
Colorado Springs, CO 80919
719-535-0407

Doug Anderson, 32
1087 Hopmeadow Street
Simsbury, CT 06070

Patrick Arrasmith, 10, 110
300 7th Street 3F
Brooklyn, NY 11215
718-499-4101

Steven Assael, 98, 124
29-57 173rd St.
Flushing, NY 11357

Michael Astrachan, 141
401 Whitney Ave. #1
New Haven, CT 06511

Armand Baltazar, 139
490 S. Marengo #4
Pasadena, CA 91101

Istvan Banyai, 8
c/o Playboy-Cortez Wells
680 N. Lakeshore Dr.
Chicago, IL 60611

Bryn Barnard, 38
432 Point Caution Drive
Friday Harbor, WA 98250
360-378-6355

Jill Bauman, 62
162-19 65th Ave.
Fresh Meadows, NY 11365
718-886-5616

Doug Beekman, 15, 50, 58
31 S. Main #4
Brattleboro, VT 05301

Wes Benscotter, 89, 100
4249 K Catalina Lane
Harrisburg, PA 17109

Rick Berry, 99, 100, 106, 112, 118, 121
93 Warren St.
Arlington, MA 02174

Joel Biske, 28, 29
159 Avalon Ct.
Roselle, IL 60172
708-894-0629

Simon Bisley, 114
60 Alverscott Rd.
Shillhouse, Catterton
Oxon, OX18 32J UK

Laurel Blechman, 59, 116
7853 Mamoth Ave.
Panorama City, CA 91402
818-785-7904

Rob Bliss, 113, 122, 123
c/o Wizards of the Coast
Sue Ann Harkey
1801 Lind Ave.
Renton, WA 98055

Richard Bober, 31
c/o Jill Bauman
162-19 65th Ave
Fresh Meadows, NY 11365
718-886-5616

John Bolton, 88, 109
c/o Liliana Bolton
16-24 Underwood St.
London, N17DQ UK

Randy Bowen, 72, 74, 80, 82
6803 SE Jack Road
Milwaukie, OR 97222
FAX: 503-786-7948

Eric Bowman, 112
11605 SW Terra Linda
Beaverton, OR 97005
503-644-1016

Norman Breyfogle, 64
1613 Washington
Calistoga, CA 94515
702-942-4019

Brom, 21, 52
2470 Huntington Dr.
Pittsburgh, PA 15241

Charles Burns, 67
c/o Kitchen Sink Press
320 Riverside Drive
Northampton, MA 01060
413-586-9525

Jim Burns, 6, 26
c/o Alan Lynch
11 King's Ridge Rd.
Long Valley, NJ 07853
908-813-8718

Carlos Butts, 138
1701 Bolton Street 3rd Fl
Baltimore, MD 21217
410-225-7671

Vincent Cantillon, 78
900 N. Grant St.
Loveland, CO 80537
970-667-4313

John C. Cebollero, 63
72-17 34th Ave.
Jackson Heights
Queens, NY 11372
718-476-9067

Travis Charest, 60
c/o Homage Studios
888 Prospect #240
La Jolla, CA 92037

David Cherry, 118
1812 Pine Oak Dr.
Edmond, OK 73013

Doug Chiang, 103, 106
10 Lincoln, Dr.
Sausalito, CA 94965

Mark Chiarello, 56
195 Hicks St.
Brooklyn NY 11201

Joe Chiodo, 60, 61, 68, 71
8472 Via Sonoma #30
LaJolla, CA 92037

Alan M. Clark, 34
209 Oceola Ave.
Nashville, TN 37209
615-356-1609

Donald Clavette, 46
63 S 500 West
Richmond, UT 84333
801-258-0709

Sean Coons, 102, 140
3127 Foothill Blvd. #102
La Crescenta, CA 91214
818-248-3923

Ray-Mel Cornelius, 132
1526 Elmwood Blvd.
Dallas, TX 75224
214-946-9405

Mark Covell, 96, 120
292 Sturgess Ridge
Wilton, CT 06829
203-834-2792

Kinuko Y. Craft, 11
83 Litchfield Rd.
Norfolk, CT 06058

Steve Crisp, 136
c/o Worlds of Wonder
P.O. Box 814
McLean, VA 22101
703-847-4251

Geoff Darrow, 94
c/o Wizards of the Coast
Sue Ann Harkey
1801 Lind Ave.
Renton, WA 98055

Joseph DeVito, ii, 35
1 Holly Court
Flemington, NJ 08822

Dave DeVries, 94, 95, 102, 114, 115
428 Lathrop Ave. Apt C
Boonton, NJ 07005-2222
201-331-8136

Vincent DiFate, 42
12 Ritter Drive
Wappingers Falls, NY 12590

Tony Diterlizzi, 44, 88
405 First St. 2nd Floor
Brooklyn, NY 11215

Les Dorscheid, 46
1415 Andaman St.
Sun Prairie, WI 53590
608-837-8697

Brian Durfee, 30
653 N. 100 West #307
Provo, UT 84601
801-375-9510

Les Edwards, 46, 53
c/o Alan Lynch
11 King's Ridge Rd.
Long Valley, NJ 07853
908-813-8718

Bob Eggleton, 28
3524 West Shore Rd. #210
Warwick, RI 02886

Francois Escalmel, 9
6964 DeNormanville
Montreal, Quebec
H2S 2C3 Canada
514-271-9897

Steve Ferris, 130
92 Clancy Rd.
Manorville, NY 11949

Fred Fields, 138
33922 Hillcrest Dr.
Burlington, WI 53105
414-539-3631

Jon Foster, 127, 136
231 Nayatt Rd.
Barrington, RI 02806
401-245-8438

Frank Frazetta, 86
c/o Frazetta Prints
P.O. Box 919
Marshall Creek, PA 98335

Brian Froud, 91
Stinall, Stiniel
Chagford, Devon
TQ 13 8EL UK

Marc Gabbana, 97, 102
2453 Olive Street
Windsor, Ontario
N8T 3N4 Canada
519-948-2418

Nick Gaetano, 30, 48
c/o Vicki Morgan Assoc.
194 Third Ave.
New York, NY 10003
212-475-0440
212-353-8538 FAX

Donato Giancola, 22, 36, 54
67 Dean St. #3
Brooklyn, NY 11201
1-800-256-0181

Chuck Gillies, 105
1721 Columbia
Berkley, MI 48072
810-353-7722
810-353-1199 FAX

Gary Glover, 18, 19
6715 Xana Way
Carlsbad, CA 92009
619-471-9453

Lars Grant-West, 140
24 Tucker Hollow Rd.
North Scituate, RI 02857
401-647-7348

Samuel H. Greenwell, 76
62 Westmont Court
Frankfort, KY 40601

James Gurney, 84, 90
P.O. Box 693
Rhinebeck, NY 12572

Scott Gustafson, 85, 104
4045 N. Kostner
Chicago, IL 60641
312-725-8338
312-725-5437 FAX

John Hanley, 64
4803 Wyoming Way
Crystal Lake, IL 60012
815-459-1123

Richard Hescox, 130
3275 Chambers
Eugene, OR 97405
541-302-9744

Stephen Hickman, 70, 83
10 Elm Street
Red Hook, NY 12571

Jay Hong, 87, 106, 116
65 N. Michigan #6
Pasadene, CA 91106

John Howe, 51
c/o Alan Lynch
11 King's Ridge Rd.
Long Valley, NJ 07853
908-813-8718

Troy Hubbs, 60
c/o Homage Studios
888 Prospect #240
La Jolla, CA 92037

Jael, 104
P.O. Box 11178
Fairfield, NJ 07004

Nicholas Jainschigg, 44
116 Kent St.
Brooklyn, NY 11222

Bruce Jensen, 23, 38
39-39 47th St.
Sunnyside, NY 1104
718-482-9125

Jay Johnson, 132
336 Melrose Dr. #3D
Richardson, TX 75080
214-231-7448

Joe Jusko, 92, 101
35 Highland Rd
Bethel Park, PA 15102

Glenn Kim, 18
768 21st Avenue
San Francisco, CA 94122

Dave Kramer, 18
3190 Carlisle #219
Dallas, TX 75204
214-871-0080

Kevin Kreneck, 44
4326 Cole Ave. Apt. B
Dallas, TX 75205

Charles Lang, 69
P.O. Box 5010 Suite 115
Salem. MA 01970-6500
508.741.0029

Todd Lockwood, 10, 116
10017 Clay Street
Federal Heights, CO 80221
303-466-6978

Jerry Lofaro, 92
18 Low Ave. 2nd Fl
Concord, NH 03301
603-228-6045

Carl Lundgren, 128
P.O. Box 825
Lecanto, FL 34460

Chuck Maiden, 62
5500 Tanoak Lane #246
Agoura, CA 91301
818-597-9261

Don Maitz, 65, 108
5824 Bee Ridge Rd. Suite 106
Sarasota, Fl 34233

Greg Manchess, 7
13358 SW Gallop Ct.
Beaverton, OR 97008
503-590-5447

Matt Manley, 111
840 First NW Apt. 1
Grand Rapids, MI 49504
616-459-7595

David Martin, 134
7990 Topeka Ave. #1
Cascade, CO 80809
719-684-9847

Pedro Martin, 75, 78
103 W 51st. St.
Kansas City, MO 64112
816-561-6217

K.D. Matheson, 100, 117
c/o Dark's Art Parlor
1405 N. Main Street
Santa Ana, CA 92701
714-647-9733

John Matson, 96
11215 Research Blvd. #1062
Austin, TX 78759

David Mattingly, 27
1112 Bloomfield St.
Hoboken, NJ 07030

Tara McGovern-Benson, 54
145 Navajo Drive
Sedona, AZ 86336

Tony McVey, 78, 80
535 Alabama St.
San Francisco, CA 94110

Ken Meyer, Jr., 64, 70
3467 Bevis St.
San Diego, CA 92111

Michelangelo Miani, 12
22052 Cernusco Lomb LC
Italy
039-990-3870

Mike Mignola, 137
c/o Homage Studios
888 Prospect #240
La Jolla, CA 92037

Ian Miller, 52, 120
c/o Worlds of Wonder
P.O. Box 814
McLean, VA 22101
703-847-4251

Jeff Miracola, 50
11160 Jollyville Rd. #631
Austin, TX 78759
512-349-7478

Chris Moore, 10
c/o Worlds of Wonder
P.O. Box 814
McLean, VA 22101
703-847-4251

Clayburn Moore, 77, 82
11906A Dubloon Cove
Austin, TX 78759

Pat Morrissey, 40
37 Amy Drive
Sayville, NY 11782

John Mueller, 57
c/o Kitchen Sink Press
320 Riverside Drive
Northampton, MA 01060
413-586-9525

Bill Nelson, 133, 134
107 E. Cary Street
Richmond, VA 23219

Mark Newman, 73, 79
281 Taurus Ave.
Oakland, CA 94611

Terese Nielsen, 90
c/o Homage Studios
888 Prospect #240
La Jolla, CA 92037

Tim O'Brien, 13, 110, 125
480 13th Street
Brooklyn, NY 11215
718-832-1287

Mel Odom, 2
c/o Playboy-Cortez Wells
680 N. Lakeshore Dr.
Chicago, IL 60611

Glen Orbik, 36, 59
818-785-7904

John Jude Pallencar, 20, 34
249 Elm St.
Oberlin, OH 44074

Jeff Pittarelli, 66, 108
P.O. Box 11767
Atlanta, GA 30355
770-384-0916

David Plunkert, 8
c/o Playboy-Cortez Wells
680 N. Lakeshore Dr.
Chicago, IL 60611

R.K. Post, 24
7900 Wolf Road
Kingston, IL 60145

John Pound, 122
5587 Noe Ave.
Eureka, CA 95503
707-444-8170

Richard Powers, 26
c/o Worlds of Wonder
P.O. Box 814
McLean, VA 22101
703-847-4251

Leah Palmer Preiss, 12
2709 Vanderbilt Ave.
Raleigh, NC 27607
919-833-8443

Romas, 25, 40, 42, 54
66 Dale Drive
Keene, NH 03431
603-357-7306

Luis Royo, 3, 30
c/o Alan Lynch
11 King's Ridge Rd.
Long Valley, NJ 07853
908-813-8718

Gary Ruddell, 17, 24, 93
875 Las Ovejas Ave.
San Rafael, CA 94903

Robh Ruppel, 5, 110
67 Cherry St.
Williams Bay, WI 53191

John Rush, 14, 129
123 Kedzie St.
Evanston, IL 60202
847-869-2078

Barclay Shaw, 131
170 East St.
Sharon, CT 06069
860-364-5974

Mark Schultz, 66
c/o Kitchen Sink Press
320 Riverside Drive
Northampton, MA 01060
413-586-9525

Tom Simonton, 66
Rt 2 Box 60
Minco, OK 73059
405-352-4702

Lisa Snellings, 76
P.O.Box 12323
Augusta, GA 20914
706-738-4132 FAX

William Stout, 104, 114, 119, 122
1468 Loma Vista St.
Pasadena, CA 91104

Stu Suchit, 13, 16
284 Fourth St.
Jersey City, NJ 07302

Tom Taggart, 74
Kings Village Apt. 314-2
Budd Lake, NJ 07828
201-426-1612

Heidi Taillefer, 132
470 6th Ave.
Verdun Quebec
H4G 3A1 Canada
514-697-8487

David Terrill, 140
4509 Broadway #203
Kansas City, MO 64111
816-753-1766

Jerry Tiritilli, 48
3939 N Hamlin Ave.
Chicago, IL 60618
773-267-4955
773-267-4998 FAX

Ezra Tucker, 135
P.O. Box 1155
Solvang, CA 93463

Joseph Vargo, 118
4377 W 6oth St.
Cleveland, OH 44144
216-351-6090

Walter Velez, 126
c/o Jill Bauman
162-19 65th Ave.
Fresh Meadows, NY 11365
718-886-5616

Ron Walotsky, 42
112 Pine Tree St.
Flagler Beach, FL 32136
904-439-1407

Chris Ware, 60
c/o Kitchen Sink Press
320 Riverside Drive
Northampton, MA 01060
413-586-9525

James Warhola, 4, 6
P.O. Box 748
Rhinebeck, NY 12572

Morgan Weistling, 107
15900 Condor Ridge Road
Canyon Country, CA 91351
805-250-1129
805-250-1525 FAX

Michael Whelan, 41, 128
P.O. Box 88
Brookfield, CT 06804

Patrick Whelan, 98
490 S. Coast Hwy Suite C
Laguna Beach, CA 92651
714-494-8175

Will Wilson, 6, 138
5511 Knollview Ct.
Balto, MD 21228
410-455-0715

Mike Wimmer, 45
3905 Nicole Cr.
Norman, OK 73072
405-329-0478

Rob Wood, 43
17 Pinewood Street
Annapolis, MD 21401
410-266-6550
410-266-7309 FAX

Janny Wurts, 49
5824 Bee Ridge Rd. Suite 106
Sarasota, Fl 34233

Paul Youll, 26
39 Durham Rd.
Esh Winning Co, Durham
DH7 9ND UK

Stephen Youll, 32, 37
296 Pegasus Rd.
Piscataway, NJ 08854

John Zeleznik, 47, 94
7307 Kelvin #10
Canola Park, CA 91306

Shawn Zents, 59
818-785-7904

This book was set in the Adobe version of the Bembo family of type.
Believed to have been originally designed by Francesco Griffo of Bologna in the 15th century,
the modern Bembo's lowercase is a painstakingly faithful version of Griffo's original alphabet
while the capitals are a composite design in the spirit of his type.

Spectrum 3 was designed on a Macintosh 7100Power PC and a Macintosh II CI.

Book design and handlettering by *Arnie Fenner.*

Art direction and editing by *Cathy Burnett* and *Arnie Fenner.*

Production and editorial assistance by *Jim Loehr.*

Printed in Hong Kong through the offices of Global Interprint
represented by *Stacy Quinn.*

ARTISTS, ART DIRECTORS AND PUBLISHERS INTERESTED IN RECEIVING
ENTRY INFORMATION FOR THE NEXT SPECTRUM COMPETITION
should write to:

Spectrum Design
P.O. Box 4422
Overland Park, KS
66204-0422